THE THETAWAVE
PROJECT

"Aliyah Marr has clearly and eloquently tackled the subject of creativity. I am particularly impressed with her understanding of attention and its role in the creative process. Her book will serve as a fundamental text in the field of creativity."

—Les Fehmi, Ph.D., *The Open-Focus Brain*

"When you make a living from your ideas, you tend to forget about things like fun. *Parallel Mind* is a practical, poetic, and playful reminder. Even those of us in the creative professions need to remember to have fun and play; it can restore the very soul."

—Bernie DeKoven, *The Well-Played Game*

"In the magic play of personal development, Aliyah Marr teaches us how to fully embrace our deepest desires and dreams. *Parallel Mind, The Art of Creativity* is a sure guide. Read it and you will grow."

—Marc Zegans, creative development advisor

"Aliyah shares some great universal wisdom—and in a nice, useable sequence—about how to recognize, enter, and work with the creative mind. She gives us some good reminders about the characteristics of creativity, as well as a synthesis of many threads of ideas that pertain to the creative life."

—Penny Pierce, *Frequency, The Power of Personal Vibration & The Intuitive Way*

"As the founder of Alchemists International, my work has shown me that the most valuable element for any transformation is creativity. *Parallel Mind, The Art of Creativity* shows how anyone can transmute ordinary thoughts into the gold of pure creative action."

—Jeffrey S. Edwards, *Alchemists International*

"This book is about the life-changing power of the creative spirit, but it will also be relevant to those who primarily work with their left-brain. As Aliyah shows, we all have deep reserves of creativity that we can draw upon to transform not only the way we interact with the world around us, but also the very thoughts and emotions that determine our reality.

Aliyah Marr's ideas are provocative, even challenging, but she presents them in vivid, accessible arguments supported by an eclectic assortment of quotations from philosophers, artists, scientists, and other famous figures. *Parallel Mind* contains the rare gift of a new, necessary angle on contemporary life."

—Benjamin Kessler, playwright & editor

"Creative thinking can make or break a business. *Parallel Mind* contains invaluable information on how to release the mental and emotional blocks that most of us encounter in creating a new business and in marketing ourselves. Highly recommended."

—Michael Port, *Book Yourself Solid*™

"Packed with actionable insights and precise tools for breaking through self-imposed limitations and barriers, *Parallel Mind* is more than a book, it is a foundation for success and inspiration."

—Stephen Sorkin, *Aha Performance*

"With a masterful blend of science, metaphors, wisdom, quotes, and storytelling skill Aliyah Marr brings the magic carpet of creativity to life. With this book we can become the creative masters of our lives."

—Sharon Lund, *The Integrated Being*

"Aliyah Marr's book provides a unique look into the development of creativity. The wide variety of ideas and approaches to creating provide something for everyone to ponder. In addition to her views, relevant quotes from artists, philosophers and others offer much food for thought."

—Bruce Wands, *Digital Creativity, Art of the Digital Age*

"For those with a vague awareness that something is missing in their lives, Aliyah makes a compelling case that personal change is possible, and the rewards immeasurable, that joy and abundance is a nano-second away. Ms. Marr isn't asking you to get to work—she's inviting you to come out and play. Who wouldn't want to join her?"

—Thornton Sully, editor-in-chief, *A Word With You Press*

"This book moves beyond ideas and concepts found in other self-help books. In a refreshing way, the author presents steps for you to take to unlock the joy you were born with and should be feeling every day. Essentially she's saying; if you aren't happy you can train yourself to fix that, you were born with all the tools you need, now its time to unlock your potential. By using creativity you can unlock and discover abundance in all the good things life has to offer."
—Mark Ninci

"Aliyah Marr's book goes directly to the heart of the creative experience. She leads the reader to the boundary of un patterned and habitual thought—pure creativity. Aliyah explores many of the different roads and perspectives to inspire your most creative self into being."
—Peter Avedisian, *Zen Machine, CosmicHill.com*

"An enlightened, engaging and provocative look at how to blend creativity and personal pursuits for a truly fulfilling life. Must reading."
—David Heenan, *Flight Capital and Double Lives*

"I found *Parallel Mind* a fascinating read. Aliyah demonstrates how you can use tools from the arts to shift your thinking and change your life. This book is an incomparable reference guide; keep it in your back

pocket until the changes that she endorses become part of you like a pair of your favorite jeans!"

—Michael A. Nitti, *The Trophy Effect*

"As a person with autism, my visual thinking mind finds unexpected associations that help me invent new ideas. *Parallel Mind, The Art of Creativity* will give you lots of new ways to look at old problems."

—Temple Grandin, *Thinking in Pictures*

"This book has a beautiful voice. It is encouraging, gentle, and kind. It speaks to you like a good friend. It's about opening your mind to become the creative person that exists in each of us. It's about opening your mind to become the creative person that exists in each of us.

So, instead of providing a catalog of quick techniques, this book goes deeper into the heart of creativity. It goes into the fundamental mind-set that drives creativity. Once you master this, then you can use the tools like an artist. And yes, the book also provides techniques.

But the real value is in the profound wisdom about how people unfold into being creative. I found this to be one of those rare books that deserves to be kept and cherished. I strongly recommend this book. It belongs in any personal library."

—Steve Kaye, IAF Certified Professional Facilitator, *stevekaye.com*

Parallel Mind

The Art of Creativity

Aliyah Marr

THE THETAWAVE PROJECT

www.aliyahmarr.com

This book and other products to aid creative development may be ordered directly from the publisher at:

www.parallelmindzz.com
tools & toys for creative people

Library of Congress Cataloging-in-Publication Data

Marr, Aliyah
Parallel Mind, The Art of Creativity / Aliyah Marr—1st ed.
p. cm.
ISBN 978-0-9821059-0-0 (ebook)
ISBN 978-0-9821059-1-7 (paper)

1. Creativity 2. Art 3. Personal Development 4. Self-help
5. Marketing 6. Psychology 7. Education

The great teachings unanimously emphasize that all the peace, wisdom, and joy in the universe are already within us; we don't have to gain, develop, or attain them. We're like a child standing in a beautiful park with his eyes shut tight. We don't need to imagine trees, flowers, deer, birds, and sky; we merely need to open our eyes and realize what is already here, who we really are.—Anonymous

"Are you up to your destiny?"—Hamlet

PREFACE

Are you ready to live the life you were meant to live? This book is about how to live a creative life; not how to paint or draw, but how to think like an artist, and how to find a joyous, complete life as a result. The power of creative thought can impel you to excel in any medium, in any field, or any subject.

Many people are creative in their daily lives, others would like to be more creative, still others would like to experience the magic that they have seen only from the outside until now.

This book answers some essential questions, the most important being: what is creativity, and how can it bring me freedom and happiness?

However, the real value of this book is not in the questions that it attempts to answer, but in the questions that it poses. These questions are traditionally asked under the cover of art, but I ask these questions here so that you may ask them of yourself.

I started out as a fine artist, and entered the fields of illustration, graphic design, broadcast design, and interactive design. As I developed my commercial skills

and artistic craft, I learned that there is a difference between *pure creativity* and *applied creativity*.

Pure creativity is an activity that has no predefined destination or purpose, while *applied creativity* is an activity that always has a goal or application in mind. Pure creativity can be seen as a kind of play, while applied creativity is usually seen as work.

Examples of pure creativity include (but are not limited to): a painter who paints from his heart, a musician who creates a symphony while toying at the piano, a writer who bases a screenplay on the people she knows at work, a scientist who discovers a new law of the universe by playing with raw materials and outlandish ideas.

Examples of applied creativity include (but are not limited to): design, architecture, scientific inquiry, technological innovations, programming, copywriting, and business development.

One form of creativity is not superior to the other. It is just easier (and more fun!) to learn pure creativity before attempting to apply creativity to a purpose. Applied creativity can be fun and playful too. However this particular book focuses on the importance of play to our development as a complete, creative individual, and so it is about pure creativity.

Parallel Mind reveals how you, as a creative individual, can mold your life with the power of your thoughts and

how those thoughts can be used to create whatever you want in life.

~ ~ ~

Chapter One, *Creativity* defines and outlines creativity: what is it, how can we use it, where does it reside?

Chapter Two, *Double Vision* is about the source of creativity—our inner child—and how we, as adults, encase this pure self in a cage of fear and limitation.

Chapter Three, *Body & Soul* discusses the relationship of the body to the mind; how to use your mind creatively to create the body you want.

Chapter Four, *Shaking the Tree* explores more deeply into the mind, how to change limiting beliefs, how to overcome fear, and encourage original thought.

Chapter Five, *Navigating a Sea of Emotions* is about emotions: why do we have them, how to choose your emotions, and how to use them effectively.

Chapter Six, *The Secret of Sex* reveals how to marshal the twin forces of passion and desire to supercharge and sustain your creative vision.

Chapter Seven, *The Conscious Creative* shows how the practice of art brings the artist increased awareness and personal power.

Chapter **Eight**, *The Infinite Self* brings together the concepts introduced in the former chapters, and shows how they can lead the artist to creative freedom.

Included in every chapter are quick in-text exercises intended to help provide a break in reading you activate the principles you have just read. They are repeated in the appendix for your convenience.

Whatever you can dream is available to you, but first you must know how to use your creative potential. An artist is not defined by his work, but by the power of his creative thought. This book gives you the tools to achieve those dreams, whether you are a creative professional, a student of art, or someone interested in personal development.

Becoming an artist does not require a mastery of technique, great skills or advanced degrees, it only requires that you take the time to *be* an artist. Art is about change, exploration, and about the courage to know yourself.

Often we don't accept a challenge because we fear change and commitment. Perhaps we are afraid, because we know deep down that a life like this takes unconditional passion, courage, and dedication. To live a consciously creative life, you have to show the forces that be that you deserve the life you want by consistently displaying these qualities. This is what Joseph Campbell calls the *Hero's Path*. Make no mistake, if you follow a path of conscious change you are walking in the very footsteps of giants.

So I ask you: when will you allow yourself the life you deserve? A voice is whispering in your ear: today is the day.

I
wish
to express
thanks and
appreciation
to all my
innumerable
teachers, but
first and fore-
most to my
parents—to
my father who
taught me
how to think
and to my
mother who
taught me how
to feel. I also wish
to say to those of
you, who like me,
always were *different*,
but didn't know why:
you're probably an artist —
you have a license to be free.
Start the incredible journey.

ACKNOWLEDGEMENTS

I'd like to thank my editor, Aaron Buczek and advisor, Marc Zegans for their expertise and support. Aaron and Marc share my dream of individual empowerment and creative freedom for everyone.

CONTENTS

"The best way to make your dreams come true is to wake up"
—*Paul Valery*

INTRODUCTION

THE ADVENTURE OF THE CONSCIOUS CREATIVE

Stories of magic and mystery permeate our cultural history, and have fascinated children and adults for untold generations. Fairy tales and mythologies are full of examples of powerful people who have the ability to generate new objects and realities out of thin air. The archetypical figures in these legends live in our collective consciousness and populate our dreams.

There is a nugget of truth hidden inside these tales. The magicians in these stories are ordinary people who have discovered an incredible power. They know what all of us should know—we are natural magicians. We should know this because it is a truth that is all around us: we modify our environments and create the world in which we live.

We are creating our realities all the time. Look around you—it is a self-evident truth. Most of us live in an artificial world of our own construction.

Everything in our man-made environment started out as a creative thought in someone's head. As the idea is caught and visualized, it starts to become more real. The original inspiration becomes denser through focus and concentration, and finally materializes into form.

So someone thinks into existence a chair, a wheel, or a computer. It is the creative thought that forms the eventual material reality. Like a fertilized egg that hatches a chick just because it was kept warm, the actual work of manufacturing the desired object is the inevitable fulfillment of conception. Manifestation is the natural, spontaneous conclusion that follows inspiration.

Creativity is our birthright as human beings. The ironic thing is that we seem to have forgotten our power as creators. We have abandoned our responsibility for our circumstances, and have given our power to remote authorities that do not have our best interests in mind. When we abandon the responsibility for our development as individuals, we give up a great deal of potential for personal fulfillment and joy. What is at stake is the most important thing to us as individuals and to humankind in general—our evolution.

I guarantee you that *you* are creative, as we are *all* creative. The life you are experiencing today is the result of the thoughts you were thinking yesterday. We

are holding our reality in existence by our focus on the elements of what we perceive to be our reality. Whether aware of it or not, we are thinking our lives into existence from moment to moment. I propose that if we are creating our lives we might as well be conscious of the process and choose what we want to create.

We are all master magicians; in fact, we are such good magicians that we have deluded ourselves into believing that we are powerless, when in fact, we are the ones in control of our lives. Whether conscious of it or not, we are creating our reality all the time. We are natural creators who have the power to create whatever we want.

When we find the power to take control of our thoughts and change our circumstances, we find true independence and creative expression. Nothing is beyond us, because in a state of conscious creation we can live without limits.

However, the average individual feels like a victim of time and circumstance, powerless in the face of what looks like an absolute and insurmountable reality. We are not as helpless as we believe; we are simply unaware of the part we play in our circumstances.

Who can help us regain our power? I have come to understand from my work as an artist that we should look to ourselves for the answers. I know of nothing that has the same potential for self-discovery and empowerment as the process of creating art.

Think about what it would feel like to release the wondrous power that resides within you. What if we are not Aladdin making wishes by rubbing a lamp, but instead, we are the Genie granting those wishes to ourselves? Does this idea frighten or excite you?

"When you follow your bliss...doors will open where you would not have thought there would be doors, and where there wouldn't be a door for anyone else."—Joseph Campbell

"The Toltecs believe that every human is an artist, and the art we create is our lives."—Don Miguel Ruiz

1

CREATIVITY

What is your most heartfelt desire? Do you know that you have the power within you to grant any and all of your wishes? Humans are natural creators. It is our birthright to be the creative architects of our lives, not just a leaf in the wind, torn between our duties and our desires.

As humans, we are uniquely gifted magicians—we have the ability to create new things and even modify our environment. Creativity is our talent and our gift, an inheritance from an abundant universe.

Beyond the sense of personal power and control that comes with the practice of art, the fringe benefit is a life filled to the brim with riches. It is impossible to be bored when the world is a playground filled with toys and tools for you to play with and use. Everything is potentially interesting and useful; every event is an

opportunity for a learning experience—a spark for a responsive, playful intellect.

Most of my lessons about how to live come from my practice as an artist. I have learned to apply the simplicity and directness of these ideas and found that they work to create whatever I want. I would like to share some of these principles I have discovered with you, so you will be inspired to seek and find your own tools to gain the life you desire.

"The world is a feeling."—Don Juan Matus

Building blocks

Just what is this talent we call creativity? Is creativity natural to all humans, or do only some people have it?

Within the context of this book I define two fundamental types of creativity: *innate creativity* and *conscious creativity*. Innate creativity is something that every human on earth has naturally, but it operates at an unconscious level. Conscious creativity is what artists develop.

An artist[1] starts with innate creativity; through the practice of art he develops a keen awareness that I call *conscious creativity.* Conscious or actualized creativity is a matter of learning a particular kind of attention or focus; the resultant mood or feeling is the essence of being an artist. This book is about how to awaken,

1 I refer to creative people as artists in this book, although not all of us are actual artists by profession; for the purposes of this book, it is a convenient term.

nurture, and mature the innate creativity that we all possess into full conscious expression.

Creativity is not limited to art forms, and it is not a learned skill. The smallest child is a natural artist, taking elements from his environment, recombining them and shaping new things. Our minds are naturally creative; perception itself is a kind of creative activity, because the brain has to interpret and put in perspective all that the senses deliver.

The eye cannot perceive without the partnership of the brain, which interprets every experience and filters it through past experiences and emotions. The eye is not a camera, and the brain is not a computer. The brain creates reality from the data that it receives, even when it thinks it is merely perceiving. It is impossible to be truly objective about anything, because of the way our brains are designed.

Natural creativity operates in all of us in every thought, and in every utterance; in every perception and in every feeling. Creativity is often repressed from full conscious expression, and lives at an unconscious level in most people. Resolving creative repression means overcoming certain mental and emotional blocks. Once those blocks are removed, creativity naturally blossoms into full conscious form.

In Western society, people often confuse product with process. A conscious creative knows that the process is the actual product, and revels in the journey

of making art. When you look at art you are seeing the by-product of the creative process. In the same way that the shed skin of a snake is a record of the animal's former shape, artwork is an imprint of who the artist was—it is a record of the creative process, a fascinating window onto the evolution of the individual.

The real product is the evolution of the artist, not the artwork that she creates. People unconsciously know that the artwork is only a snapshot of the artist, a record of who she was when she created it. Art collectors are often trying to buy a "piece" of the artist, a souvenir of a person or life that they admire.

> *"You're confusing product with process. Most people, when they criticize, where they like it or hate it, they're talking about product. That's not art, that's the result of art. Art, to whatever degree we can get a handle on (I'm not sure that we really can) is a process. It begins in the heart and the mind with the eyes and hands."*
> —*Jeff Melvoin, Northern Exposure, Fish Story*

Art stops time in order to teach, expose, or reveal things that are normally hidden. Art patrons want to purchase the object that represents what they felt or saw to preserve it for future contemplation.

In owning the object, they feel that they own the lesson or the experience. It is a way to possess time, and

slow life down. Like a souvenir of a great trip, people want a way to remember their feelings, and freeze their knowledge in solid form.

Art imitates life imitates art

One can transport the lessons learned in making art over to the creation of one's life. Taken one step further, it is possible to approach life as a work of art. For that, we need to free our natural creativity.

> *"Paradoxically though it may seem, it is none the less true that life imitates art far more than art imitates life."*—Oscar Wilde, In Art

When I was in art school, one of the questions the instructors posed to us was "What is art?" The real question is: "What is creativity and how do we work with it?"

Many of us do not understand, first, that we all have this power of creativity; second, no one seems to know where it exists; third, few people know how to tap into this amazing faculty. If you watch a small child, you can see that he is naturally creative; a child spontaneously draws and paints, imagines worlds of his own, and makes up songs and stories.

This observation of children has convinced me that creativity is innate to everyone. We have this amazing, powerful gift until the very first moment

that someone criticizes us. Then this marvelous ability goes underground, so to speak, into province of the inner child.

The qualities that all children exhibit are very close to those of the creative individual—the ones that most adults have learned to suppress. Following are the principles of creativity that I have discovered in my career as an artist:

1. Creativity is play without purpose. A child simply wakes up in the morning and starts to play. He has no agenda, timetable, or plans. An adult, on the other hand, makes an endeavor out of play; he cannot conceive of engaging in any activity without a goal or prearranged structure. A child does not think about problems or structures; instead he accepts what is and spontaneously plays. It is only later, once creative freedom has been experienced, that a creative individual can harness the creative impulse to a defined purpose.

However, any creative activity with a defined goal—such as solving a problem—never has quite the same taste of freedom as the practice of play without purpose. For the purposes of this book, when referencing creativity, I am referring to *pure creativity*—the kind of creative action that has no beginning intent other than the sheer joy of play.

In contrast, creativity that has commercial value or practical application is *applied creativity*. I have a good

reason for emphasizing pure creativity—in the same manner that a child has to learn to crawl before he can walk, so an artist has to first learn the pure creative form, before being able to effectively practice applied creativity.

2. Creativity is unconventional. The creative mind looks at the world with the eyes of a child, without prejudice or knowledge. From this unbiased perspective, there is nothing that cannot be fascinating in and of itself. This is the value of creative focus, a kind of honing in and really looking at something with deliberate naiveté.

> *"The arts, and learning about the arts, are not additions to life: they are life itself, an expression of life that feeds back into it and helps to make it what it is—and, above all, to show it what it is, to make life conscious."*
> —*Clive James, Cultural Amnesia*

In her book, *The Creating Brain, The Neuroscience of Genius*, Nancy C. Andreasen says: "Creative people tend to approach the world in a fresh and original way that is not shaped by preconceptions. The obvious order and rules that are so evident to less creative people, and which give a comfortable structure to life, often are not

perceived by the creative individual, who tends to see things in a different and novel way.

"This openness to new experience often permits creative people to observe things that others cannot, because they do not wear the blinders of conventionality when they look around them."[2]

3. An artist is a keen, detached observer. An artist will often feel as if he is watching a movie of life, detached from the participants. The perspective that unbiased observation gives the artist is key to the creative process.

> *"I slip into a state that is apart from reality. I don't write consciously—it is as if the muse sits on my shoulder"*—Neil Simon

4. Creative thought involves the capacity for introspection and time for incubation. Without the ability to be alone with one's thoughts, a creative concept cannot develop. I like to call this developmental stage the *incubation period*. This period of time varies: from a few minutes to days to years. The creative mind is always working on something, often at the subconscious level. I can be doing something completely mundane, but I am often unconsciously working on a creative project at the same time. At some point, an idea will feel as if it is bobbing to the surface, and I have a starting point.

2 Nancy C. Andreasen M.D., Ph.D., *The Creating Brain, The Neuroscience of Genius* (New York: Dana Press, 2005), 31

5. Creativity is direct and spontaneous. Think about any child whom you know. When do they want to do something? Now! Not in the distant future. How do they want to go about it? In the most direct route possible. They do not want to consult with experts, read manuals, or talk about it at the conference table. They create whatever they want with boundless enthusiasm, spontaneity, and directness. Again and again in my art and in my design practice I am reminded that the best route to the final piece is always the simplest, most direct one.

6. Creativity is fearless immersion. An artist is not afraid to dive fully into whatever is before or around him. Called an immersion experience, this rapturous, fully absorbed state can be the result of a sensual, or intellectual appreciation. It is a common experience in both the creative process and the appreciation of art.

Les Fehmi and Jim Robbins, in their book, *The Open-Focus Brain,* cite immersion as a major component of Open Focus™ awareness and claim that Open Focus is fundamental to creative attention and peak performance.[3] As an artist, I have found the state of Open Focus to be one of the deep inner rewards of working creatively.

3 Les Fehmi and Jim Robbins, *The Open-Focus Brain,* (Boston: Trumpeter Books 2007, 50
Open Focus™ is a registered trademark of Biofeedback Computers, Inc.

As an athlete, I have experienced the same feeling in a peak performance, when I know error is not possible. It also occurs in meditation. However, I have found that the practice of art is the easiest, most reliable way for me to shift into a state of rapturous, blissful immersion.

7. Simplicity is to creativity as the match is to the flame. The initial creative spark is simple in nature. In order to find that brilliant simplicity, one has to practice thinking simple. Artists practice deliberate naiveté and innocence to the world around them.

8. An artist knows how to shift focus for inspiration and knowledge. Creative inspiration is often sparked by a shift in focus. An artist is a master of shifting focus. Often called cropping by painters, a new composition or a new subject is achieved by simply getting nearer or father away, or by shifting the center of attention to change the subject of the composition.

We can gain a new perspective on something by "reframing" it. A creative person learns early to find interest and to select a subject by shifting focus.

9. Limitations are advantages. An artist or a child simply accepts whatever is in front of them, as tool, toy, or environment, and proceeds from that point. Part of what is invigorating about the creative process is that it can start from humble materials and poor beginnings.

There is a term in painting called "working with a limited palette;" a deliberate choice to work with fewer colors than those that are actually available. Within narrower parameters an artist can work more easily—less colors actually inspire her to creative resolutions.

As a designer, I am often called upon to work with existing elements: logos, color palettes, slogans, etc. I see these constraints as elements that actually help me; it is the limitations that help me free my creative imagination.

> "*Simplicity is the ultimate sophistication.*"—*Leonardo da Vinci*

Contemporary artist Vik Muniz uses everyday materials to replicate classic artwork. He has used chocolate syrup to render Leonardo da Vinci's *Last Supper,* and has recreated the *Mona Lisa* with peanut butter and jelly. He uses what is around him—from spaghetti to toy soldiers—as the "paint" for his paintings.

Like a child who doesn't wait for the perfect tool or circumstances, an artist makes art from what he has around him. The artist sees inspiration where the ordinary person sees only a limitation or an obstacle.

10. The creative process usually proceeds from the simple to the complex. In a drawing, one starts out with simple shapes, say an oval to represent the face in

a portrait, then, as the drawing progresses, one slowly adds complexity and finally adds the detail. One does not start with the strands of the hair or with the detail of a single eye in the center of the page.

Art students who do it this way find themselves trapped by their own process; they have to erase the beautifully drawn detail because the rest of the portrait now does not fit on the page. A properly executed piece allows plenty of time to add complexity later.

> *"The whole is simpler than the sum of its parts."—William Gibbs*

The accomplished artist often has to rediscover the essence of things after having learned the skills and complexity of his craft. This was the journey of both Picasso and Matisse.

Picasso traveled from the skill and knowledge of an accomplished artist to a childlike naiveté, producing art of ingenuous simplicity. Matisse, despite a medical condition that made it difficult to control a paintbrush, did some of his best work of his life when he finally resorted to creating art by cutting out simple shapes in paper.

11. Creativity is a lifelong romance with knowledge. A romance is not based upon knowledge but upon intrigue, curiosity and mystery. An artist is romanti-

cally involved with his subject—he loves the *pursuit* of knowledge, not the possession of information. He is like a hunter who has given up his gun for a camera—no longer does he have to kill his prey; he merely pursues it to appreciate its beauty and mystery.

An artist actively nurtures his curiosity. As a teenager I liked to read scientific treatises, however, I usually could not remember the conclusions of any article that I read. It was the question that intrigued me, not the answer. A creative person does not mindlessly store data like a computer; instead he skates on the surface of information, much as a skater skims along on the surface of the ice.

The creative person *dares* to ask the simple question. She knows that it is really only the question that is important, not just because the answers keep on changing, but because feeding the imagination is key to creative growth.

12. Creativity is not judgmental. Creative thinking cannot live in a critical environment. The initial stage of any creative endeavor can only thrive in an open, non-judgmental environment. In the brainstorming process an artist does not censor her ideas. She feels a flood of concepts, sensations, and thoughts racing by so fast that it is difficult to put them down.

In order to provide the necessary environment for inspiration, there has to be allowance for anything,

and this often involves what Nancy C. Andreasen aptly termed a "tolerance for ambiguity." She says, "Creative people...are quite comfortable with shades of gray. In fact, they enjoy living in a world that is filled with unanswered questions and blurry boundaries."[4]

13. Creativity depends upon unbiased observation. Edward Tufte, in his book *Beautiful Evidence*, has an eloquent term for this: he calls it "intense seeing." "Science and art have in common *intense seeing*, the wide-eyed observing that generates empirical information."[5] It is necessary for the artist to become an observer, even of his own drama or tragedy. Comedians observe things that others ignore: the result is humor: a way to bring the audience to a different perspective—one of the primary functions of art.

> *"A creative man is motivated by the desire to achieve, not by the desire to beat others."*
> —*Ayn Rand*

14. Creativity often involves lateral thinking. Artists and scientists pose a "What if..." question to explore regions of the imagination. It can take courage

4 Nancy C. Andreasen M.D., Ph.D., *The Creating Brain, The Neuroscience of Genius* (New York: Dana Press, 2005), 31
5 Edward Tufte, *Beautiful Evidence*: Graphics Press LLC

to act from such vague and uncertain territory the first few times, but the rewards are great.

Critical thinking is primarily concerned with judging the truth value of statements and seeking errors. Lateral thinking is more concerned with the movement value of statements and ideas.

Consider the statement 'Cars should have square wheels.' When considered with critical thinking, this would be evaluated as a poor suggestion and dismissed as impractical.

The lateral thinking treatment of the same statement would be to speculate where it leads. Humor is taken intentionally with lateral thinking. A person would imagine 'as if' this were the case, and describe the effects or qualities.

Someone might observe: square wheels would produce very predictable bumps. If bumps can be predicted, then suspension can be designed to compensate. How could this car predict bumps? It could be a laser or sonar on the front of the car. This leads to the idea of active suspension. A sensor connected to suspension could examine the road surface ahead on cars with round wheels too...The initial 'provocative' statement has been left behind, but it has also been used to

indirectly generate the new and potentially more useful idea.[6]

15. The artist exposes his heart and soul. The artist pours heart and soul into his work, fearlessly baring his innermost self to the world through his art. Through the medium of his honesty and passion he connects with the viewer's heart and soul. When art fully engages you can feel a tug, a connection that goes beyond mere aesthetics or sentimentalism. This is the epiphany of art to which Joseph Campbell refers.

> *"And that 'Aha' that you get when you see an artwork that really hits you is, 'I am that.' I am the very radiance of energy that is talking to me through this painting."—Joseph Campbell*

16. Creativity is passion sustained. An artist uses his passion for his art, media, or subject to sustain him through the process of creating whatever he has decided to create. Emotions are key to both creative development and expression.

The artist uses emotions to help him manifest and channel his work. His passion is what communicates to his audience, not the work itself.

6 Wikipedia contributors, *Lateral thinking*, Wikipedia, The Free Encyclopedia, http://en.wikipedia.org/w/index.php?title=Lateral_thinking&oldid=157668328 (accessed September 20, 2007).

17. The creative mood is one of ease, lightness and play. Think of a child playing; he is focused, but not rigid or serious. He plays but doesn't need the play to go one direction or another. When he is done playing with his ball, he goes to play with his paints or his toy car—no regrets, or attachments. In the same way, the creative person can flow effortlessly from one thing to another. There is a natural flow and ease to everything.

The best tool of the creative individual is his mind, or rather, his attitude. The artist practices an attitude of easy, lighthearted playfulness—even if the subject matter is serious. These are the natural attitudes of any child, therefore of your creative inner child as well.

The *Case Study Method* work of psychologists trying to define common features of creative people in various fields revealed the following: "Personality traits that define the creative individual include openness to experience, adventuresomeness, rebelliousness, individualism, sensitivity, playfulness, persistence, curiosity, and simplicity."[7]

18. The creative attitude is one of limitless opportunity. Think of an open space, a clear horizon representing endless possibilities. A creative person is standing at the center of the universe, with infinite paths going in all directions; the unknown is exciting, and the path chosen is simply one of personal predilection.

7 Nancy C. Andreasen M.D., Ph.D., *The Creating Brain, The Neuroscience of Genius* (New York: Dana Press, 2005), 30

19. Creativity is nonlinear synthesis. The practice of art is not about data storage or logical computation, although the creative person may use unrelated data and recombine these items in new ways. The synthesis of creative thought is a completely different way of thinking than that which we commonly use.

Creative thinking is more related to intuition than to logic and learning. In fact, in order to access the kind of insights and "silent knowledge" that come with creativity, one often has to forget all one has learned.

"I do not seek. I find."—*Pablo Picasso*

20. The creative process is not a search for anything in particular but an unending series of amazing discoveries. Like an interesting walk in the forest or by the sea, for an artist life is a series of fortuitous discoveries, happy accidents, unexpected inheritances, and found treasure.

21. A creative mind questions everything. Creative thinkers have a long history of being willing to look foolish, and often go against common sense or against the "wisdom" of the times. Da Vinci defied the authorities to study human anatomy, and we have all benefited as a result.

Christopher Columbus dared to risk his life and fortune on the idea that the world might be round

instead of flat, as everyone else believed. It must not be underestimated how much courage it takes to question the status quo. We still have maps from the 15th century that contain frightening images of the horrible man-eating creatures that lived at the edge of the known world, and at the edges of their minds. The maps warn the reader, "Here be monsters!"

In every century there will be naysayers and traditionalists whose interest is in maintaining the status quo. The role of the artist is to be at the forefront of the evolution of consciousness. His job is to question ideas, beliefs, and structures.

22. An artist practices artlessness. An artist nurses an attitude of simplicity and deliberate naiveté. She often asks childlike, simple questions of herself and of the world at large. This cultivated simplicity is often the mark of a great thinker.

Real magic

Creative thought might have evolved as a tool to help mankind survive, but this doesn't explain the fact that many of the things that we create have no pragmatic purpose. Pure creativity may not have a practical function, however, it does have an effect. Like the wind that ripples the water of a lake but remains unseen, creative thought is best known through its

influence. In its purest form, creativity is uncontrolled and impractical. It is in this very impracticality that the true value of creativity resides.

It has been proposed that what distinguishes the human animal from all other animals is not opposing thumbs or language, but the artistic impulse. The true function of creativity is the evolution of the mind and of the self. The effect of conscious thought and creative action is the good health of the individual in mind, body, and spirit.

In her act of creativity, the artist connects not only with herself, but she taps into the power of the universe. An artist has a privileged occupation: the observation of and practice of real magic.

"Every child is an artist. The problem is how to remain an artist once he grows up."—Pablo Picasso

2

DOUBLE VISION

Joseph Campbell stated that the flower of Western culture is the individual. He meant that, in the West, we place our highest value upon personal achievement. To Campbell the artist is the highest expression of individuality.

Eastern philosophies strive to enable a seeker to obtain the bliss of nirvana, a state in which individu ality and the worldly self no longer has any meaning or existence. In the last 50 years, many people in the West have adopted a similar ideal, and strive to erase the individual ego in their search for enlightenment.

Before we throw anything away—especially something as basic as the ego—we should at least try to understand what we are rejecting. Most people try to understand by listening to what others say. Artists embrace what they are trying to understand. It seems to

25

me that it is not so much a matter of getting rid of your ego, but a matter of making your ego healthy. The ego must have some use to be in existence: after all, it is hard to find a human being on this earth without an ego. But it is the ego that recognizes separation in establishing individuality; it is in the expression of the ego that we first experience duality.

Dualism is expressed everywhere in nature, from the pairing of genes, to the male and female of most species, to the two halves of the human brain. We often talk of being of two minds, and we talk romantically of finding our better half, or our soul mate.

> "When asked the ultimate narcissistic question by another follower—'What is the nature of the self?'—the Buddha responded that there is neither self nor no-self. The question, itself, was flawed, the Buddha implied, for it was being asked from a place that assumed that the self was an entity."—Mark Epstein, M.D., Thoughts Without a Thinker

Dualism operates at a subconscious level in the human psyche. A number of years ago I observed that people operate with a kind of schizophrenia.[1] Everyone seems to have two distinct identities: an adult self and

1 Schizophrenia is from a Greek word, meaning "split mind." The true scientific term for the kind multiple personality disorder that I mean to suggest is "dissociative identity disorder": the idea that two personalities can exist simultaneously in the same person.

an inner child. These two personas develop as a coping mechanism during the process of attaining maturity.

The limitless child

The child is the more natural, original self; it started at the birth of the individual. For a time during childhood it is the only person. Its response to the world is pure and direct in its approach. The child persona, alternately called the inner child, is where the pure creative spark of inspiration resides. Like Peter Pan, the inner child exists in a timeless state; it never grows up or dies.

The child self may be further divided into two distinct personalities, reflecting childlike or childish qualities. The adult is the self that develops as a necessary result of the pressures of socialization. In this person is found two sides as well: the rational and the irrational.

"The most potent muse of all is our own inner child."—Stephen Nachmonovitch

The benevolent guardian

The adult personality is usually modeled upon the adults we had around us as we were growing up. In a real sense the parent persona that develops inside us replaces the parent outside at some point in our lives—usually long before the death of our parents.

Just as our parents are our natural guardians, so the original purpose of the adult personality is that of guardian as well. This self becomes a shield to protect and nurture the natural self, or inner child.

> *"I think my work as an artist has been inspired as much by toy stores as museums. I judge my maturity as an artist by my ability to communicate to children, to be like one of them. You are only young once—but that can last a lifetime."*
> —*Vik Muniz*

It is in the child self that all true creativity originates, not in the adult. The adult self merely provides a safe place and a structure for creative expression. It is from the inner child or inner spirit that creativity naturally flows. The purpose of the child self is to provide inspiration and even direction for the healthy individual. The role of the healthy guardian-adult is as a kind of personal assistant for the inner spirit/child, taking care of all the details that make manifestation possible.

The partnership of selves in the average individual is functional to a greater or lesser degree. When fear, distrust, and misunderstanding are present, the benevolent guardian turns into a tyrannical guard. The protective shell of the adult self hardens into a cage that keeps the creative inner child/spirit prisoner.

When I taught drawing classes at the School of Visual Arts in New York City, I saw that the minds of most people—even art students—are so trapped inside the tyrannical adult mind that their hand cannot draw a free line. It is as if there is a tiny judge sitting on their shoulder criticizing their every move. They are starting out with the erroneous idea that whatever they do can never be good enough.

In contrast, a child plays without judgment or purpose. In fact, that is what pure creativity is: play without purpose or goal. The purpose of play, if there is one, is the sheer joy of playing.

The two sides of the person—child and adult—establish an ongoing internal dialog that can become an argument or even a battle for supremacy over the control of the self. As the adult becomes more irrational and tyrannical, the child reacts in progressively more and more childish behavior. Or worse, the child, not allowed natural expression, finds ways to sabotage the best efforts of the adult

An example of this is the dieter who makes a morning resolution to lose weight. The tyrannical adult self practices self-discipline by not eating anything more than a tiny salad during the day. At midnight, the child self revolts against this unnatural tyranny by eating a whole gallon of ice cream, excusing herself by saying "I'm starving!" "It's OK, it has milk in it, and milk is good for me."

The adult self responds to the tantrum by feeling guilty after the ice cream is consumed, and resolves to not eat anything again the next day, "You have eaten all your allotted calories, you can't have any more food. You deserve to go to bed hungry," she says to the unrepentant, sulking child.

By this time, the authority of the adult persona has been so eroded by its own reactionary and irrational approach that neither believes that she is capable of carrying out any of her resolutions. The child self has achieved her dubious reward of subverting the good intentions of the adult, but her victory doesn't make her happy. And so on, ad nauseam.

Some people never get out of this dysfunctional relationship between their two selves. They cycle endlessly between the spoiled child self and the petty, contradictory, tyrannical adult. The worst of it is that the battle of the two selves is an enormous waste of energy that could be better spent creating what you want in life.

> *"Reason's last step is the recognition that there are an infinite number of things which are beyond it."*—Pascal

Can I have a witness?

Before we can choose different thoughts, we have to first know what they are. The first step to knowing what is going on in your subconscious is to bring all the agree-

ments and internal dialog to the surface. I recommend you keep a notebook tracking all the judgments you have during the day; good or bad, it doesn't matter, these are the thoughts you haven't been aware are there.

These subconscious judgments keep us inflexible and impervious to change. They keep us from having new thoughts, or new experiences.

1

RECORD YOUR INTERNAL DIALOG

We all talk to ourselves, whether we do it out loud or not. The problem is that these opinions and negative thoughts are going on at a subconscious level. Bring them up to the surface by keeping a diary of your internal dialog throughout the day. You might be amazed at what is being said about you by your other self, and what thoughts are defining your world.

Be prepared to do a lot of writing, and to be surprised at what you are actually thinking. We all have thoughts that do not serve us. No matter what your thoughts are, be assured that they are creating your reality. For now, just find out what they are; do not judge yourself for having them.

The healthiest thing to do is to merely recognize that you have these thoughts and judgements—realize that they are not solid or real. Don't identify with your thoughts: this is the first step to what the Buddhists call "detachment," and the pathway to mental clarity.

You can do what you want with this notebook after you have completed it: burn it, or dispose of it ceremoniously. Better yet, include it somehow in your art. By treating your thoughts as art, you put those thoughts outside yourself, and have power over them; meaning you can choose what thoughts you want to focus on. By enacting a ceremony of disposal or art, you reinforce the idea that you are closing a page in your life, one of unconscious thoughts, beliefs and behaviors.

It takes two halves to make a whole

The first challenge of the creative individual is to get back to the healthy expression of each of our selves. A whole individual integrates the rational guardian with the childlike self. A healthy adult self provides the inner child a safe place to play, and the child feels free to create.

When these two personas are functioning properly, the thoughts, desires, words, and actions of the individual are congruent. The inspiration of an inner child's creative desire is smoothly carried by the adult self into full manifestation. No energy is wasted in useless inner arguments, or in wavering between multiple choices.

The path from creative desire to attainment is direct and effortless, and life feels joyous and free.

How does one align the desires of the inner child with the rational adult? It is a matter of redirection, not a matter of resistance or denial. Rather than saying no, try simply redirecting attention; rechannel it into a different direction. The healthy use of one's energy becomes a preference after a while.

You don't have to deny yourself anything anymore. Know that you can give yourself everything you ever wanted, in the moment of *right now*. As the inner child learns that it will no longer be ignored or denied, it starts to want what is good for it. It takes healthy to recognize healthy. Simply get out of your own way; allow yourself to be a sane, drama-free, and integrated individual.

Parallel minds

What is true creativity, and how does it relate to the normal functioning of the human brain?

Richard Bergland states it thus, "You have two brains: a left and a right. Modern brain scientists now know that your left-brain is your verbal and rational brain; it thinks serially and reduces its thoughts to numbers, letters and words...Your right-brain is your nonverbal and intuitive brain: it thinks in patterns, or pictures, composed of 'whole things', and does not comprehend reductions, either numbers, letters, or words." [2]

2 Richard Bergland, *Fabric of Mind* (New York: Viking Penguin, Inc., 1985)

The right-brain exhibits the following dominant processes: rhythm, spatial awareness, Gestalt (holistic comprehension), imagination, daydreaming, color, and dimension. The left-brain excels in words, logic, numbers, sequence, linearity, analysis, and data. It has been noticed by researchers that, "When the left cortex is engaged in these activities, the right cortex is more in the 'alpha wave' or resting state." [3]

While it is easy to draw the conclusion that creative function is "right-brain," scientists have noticed that all highly creative people have learned how to develop and use both sides of the brain.

Although there is new scientific evidence that functions such as language are not the sole province of just one hemisphere, for the purposes of this book I will stick with the broader classifications of brain functions: the left as the logical and linear brain, and the right as the creative, intuitive brain.

The right-brain, which is intuitive, holistic, and nonverbal, is analogous to our definition of our inner child. The left-brain—rational, linear, and verbal—is the equivalent in my analogy to our adult self.

For our purposes, we may say that the right-brain is creative inspiration and synthesis, while the left-brain is data storage, analysis, and execution. For the accomplished conscious creative, the left-brain serves as the personal assistant for the right-brain: it uses data and

3 Tony Buzan, *Use Both Sides Of Your Brain* (New York: Plume, Viking Penguingroup, Inc., 1991), 17

acquired skills to execute the inspiration that comes from the right-brain and bring it into form.

"Symphony…is the ability to put together the pieces. It is the capacity to synthesize rather than to analyze: to see relationships between seemingly unrelated fields; to detect broad patterns rather than to deliver specific answers; and to invent something new by combining elements no one else thought to pair."[4]

Synthesis—the ability to recognize the larger pattern or picture—is the function of the right-brain, while the function of the left-brain is to put that creative synthesis into context and form. An artist constantly shifts between right and left-brain function; she doesn't spend her time exclusively in one or the other. Often the artist can feel her thoughts switching from one kind of thinking to the other kind of thinking—from the unfettered freedom of the right-brain to the controlled analysis of the left:

Step 1: right brain—exploration/brainstorming
Step 2: left-brain—choose direction and medium
Step 3: right-brain—play/work
Step 4: left-brain—step back and analyze
Step 5: repeat previous steps as often as necessary
Step 6: both brains—incorporate/communicate
Step 7: left-brain—cleanup/finish/frame

4 Daniel H. Pink, *A Whole New Mind: Moving from the Information Age to the Conceptual Age* (New York: Riverhead Hardcover, 2005), 130

This process may well be different for different individuals; in fact it differs from medium to medium for me. Despite the differences in execution the one constant is that I use the right brain for inspiration and play, while I use the left to integrate, translate, and manifest the work into a form that adheres to principles of structure and communication.

In writing poetry, I often just start with a phrase and the thing seems to evolve on its own. The end product is often very different than what it was when I started.

This is a very exciting way of doing things—novelists often talk about how characters suddenly emerge, each with a distinct voice, and sometimes they even take over the direction of the entire novel. This sounds very right-brain to me.

> *"It took me four years to paint like Raphael, but a lifetime to paint like a child."*—Pablo Picasso

I have executed paintings and videos that evolved in this organic, right-brain way. But the fact remains: in any creative process both brains have to be involved, no matter the actual process.

Parallel processing

No matter what you think may be happening, you are always thinking with both brains. In computer lingo, this is called "parallel processing"—when the

hard drives of two (or more) computers work in tandem to execute a task at double speed. This term has been imported into the study of the human brain to explain what is happening with the two sides, but the analogy fails when trying to completely describe the amazing abilities and the complexity of the human brain — especially the holistic right-brain.

Unlike the parallel processors of the computer, which work on the same program in tandem, each brain may be focused on entirely different things. You even may be ignoring the thoughts and information coming from one whole half of your brain—the right side.

> *"Each painting has its own way of evolving...*
> *When the painting is done the subject reveals*
> *itself."—William Baziotes*

The problem is that the left-brain often doesn't recognize the value of right-brain way of thinking. One may have a realization in the right-brain that isn't recognized until it hits the left-brain: the "aha" or epiphany of synthesis seems to need words to feel "real." So the information from the right-brain is sometimes useless to the individual unless the left translates it.

Unless there is this recognition and communication between the two brains, the creative individual is not truly whole and functional. To not recognize the

input of one brain hemisphere is like ignoring one half of every book you read.

Each of your eyes is connected to the opposite side of your brain; the left translates the information from your right eye, while the right translates the data from the left eye. In a case described by Dr. Oliver Sacks in his book, *The Man Who Mistook His Wife For A Hat*, a woman with brain damage in one hemisphere could only see half of everything before her: she could make up only half of her face, read half a page, and eat only half of her dinner.

Like a bizarre real life proof of Zeno's *Paradox of the Race*,[5] she was condemned to be only capable of closing half the distance to the comprehension of the whole by eternally dividing that whole in half and then in half again; it was even difficult for her to conceive that what she saw was only half of everything—she always thought she was seeing it all.

Her brain, made for holistic comprehension, was no longer whole; she was tricked into believing that her perception was integrated when, in fact, she was receiving only half the information before her.

The two sides of the brain process the same input differently because of the way the two hemispheres are designed to perceive. Scientists have discovered that the

5 Zeno's *Paradox of the Race Course* states "motion is impossible, because an object in motion must reach the half-way point before it gets to the end." (Aristotle, Physics 239b11-13).

right-brain is the one that processes new information; like the temporary memory, or RAM, on a computer.

When the information is no longer new, it is sent to the left-brain for analysis, categorization, and storage. One could say that at this point the information is data stored in the left-hemisphere's permanent memory or hard drive.

The left hemisphere controls the right side of the body; while the right hemisphere controls the left side of the body. Perception and memory is also divided between the two sides of the brain.

2

ACCESS YOUR INTERNAL WISDOM

Take a sheet of paper and use it to send messages from your subconscious. It is said that normal consciousness is expressed by the dominant hand (right hand in most people), while the subconscious can be accessed by writing with the non-dominant hand. State a personal problem with your dominant hand on the corresponding side of the paper, and answer with your non-dominant hand on the other side. Repeat until your thoughts can flow freely. Sit back, admire your work.

There are a series of marvelous experiments in the book, *The Other Mind's Eye*, by Allen Sargent. The researchers' findings indicate that the inner eyes of the mind see our experiences and memories differently. Most of us have a dominant eye and a corresponding dominant brain hemisphere that colors all perceptions and therefore all our experiences.

When a volunteer "looked" at a traumatic memory with her non-dominant eye the size of the remembered perpetrator shrank, while the trauma of the experience lost the emotional charge and the memory suddenly became manageable. The researchers were astonished by the implications of their experiment. Simply by switching the hemisphere of the brain in charge of translating the memory of the experience, the impact of the memory changed.

> *"The intuitive mind is a sacred gift and the rational mind is a faithful servant. We have created a society that honors the servant and has forgotten the gift."—Albert Einstein*

Our society tends to value only the left-brain mode of thinking. It puts intuition and psychic abilities into the questionable category of human activity. Overly rational people often dismiss intuition and imagination as the workings of an unhealthy, feverish mind.

Although much information comes from the right-brain, the average person is not even aware of it. Most people don't understand anything that cannot be translated into something the left-brain can comprehend.

The left-brain regards most intuitive knowledge as undependable because we have been taught to distrust anything that is not quantitative or capable of being expressed verbally. This is one of the problems of a predominantly left-brain civilization. Our culture has, for all practical purposes, cut the connection to our mysterious creative center—our right-brain.

"The stronger the imagination, the less imaginary the results."—Rabindranath Tagore

Psychologist Michael Gassaniga studied the brains of epileptic patients who had surgery that cut the tissue—the corpus callosum—connecting the two brain hemispheres. This is analogous to severing the Ethernet cable connecting parallel hard drives.

Normally the brain hemispheres work in tandem to solve a single problem—that of perception and orientation. Gassaniga tested his patients by showing each eye a different image. The image shown to the left eye—controlled by the right hemisphere—could not be identified verbally, because the visual right side of the brain, cut off from the verbal left-brain, could no longer

access the words for those objects. If asked to identify which of a series of subsequent images belonged with the original image, the patient had no trouble, because the right side of the brain is image-based.

"…Gazzaniga refers to the language centers on the left side of the brain as the interpreter module, whose job is to give a running commentary on whatever the self is doing, even though the interpreter module has no access to the real causes or motives of the self's behavior. For example, if the word 'walk' is flashed to the right hemisphere, the patient might stand up and walk away. When asked why he is getting up, he might say, 'I'm going to get a Coke.' The interpreter module is good at making up explanations, but not at knowing that it has done so."[6] Further, it has been shown how, in some split-brain patients, the two hemispheres may actually fight each other. The left hand, controlled by the right hemisphere, reaches for an object, only to be arrested in mid-grab by the right hand, trying to prevent it from executing the wishes of the other hemisphere of the brain.

These studies prove that the world "out there" is not as concrete as we have led ourselves to believe. The woman with right-brain damage who made up only one half of her face was incredulous when told she had not done her entire face.

6 Jonathan Haidt, *The Happiness Hypothesis, Finding Modern Truth in Ancient Wisdom,* (New York, Basic Books, 2006), 8

In the same way, it may be difficult to conceive that everything in our lives is just a story that we tell ourselves. Our idea of reality may always be suspect until that day when we not only admit the workings of another side of ourselves, but begin to welcome its input.

Our minds create the problems that they like to solve

In the world of a creative person, problems do not exist; everything is simply a material, tool, or toy. An artist talks about his product as his "work," but an artist's work is really a kind of serious play.

> *"The opposite of play isn't work. It's depression. To play is to act out and be willful, exultant and committed as if one is assured of one's prospects."—Brian Sutton-Smith, Professor Emeritus of Education, University of Pennsylvania*

The problems that the artist encounters along the way are not seen as obstacles to overcome, but rather as something to examine for their inspirational value. What others perceive as a problem is a springboard for a somersault of thought, the inspiration for a leap of logic. From this new viewpoint, a whole new universe unfolds before the eyes of our creative imagination.

Why is pure creativity not problem-solving? It is because the mere perception of something as a

problem sets it up in the left-brain as an obstacle that it must conquer. The left-brain tries to solve or defeat the obstacle, in the process shutting off the right-brain; any input from that side is ignored as nonsensical and impractical to the linear, quantitative left-brain.[7]

> "...if the intuitive visitor is given a royal welcome when he comes, he will come again; the more cordial the welcome the more frequent his visits will become, but if he is ignored or neglected he will make his visits few and far apart."
> —*Charles F. Haanel, The Master Key System*

Einstein said, "You can't solve a problem with the same mind that created it." Notice that he is saying that it is the mind itself that has created the problem; the problem he is referring to resides solely in the left-brain. Problems simply don't exist in the right-brain. Whatever is perceived there is either a tool or an inspiration, and these are for play, not for problem-solving.[8] Problem-solving is in the realm of *applied creativity*.

There is a great deal of information and knowledge that comes from the intuitive side of the brain. The form that this knowledge takes is amorphous; it often

7 For the purposes of this book, left-brain thinking is called "applied creativity" and right-brain thinking is called "pure creativity."

8 I am not saying that problem-solving is not creative, but to develop pure creativity, it is necessary to end left-brain dominance; thus I make the distinction here between pure and applied creativity. Problem-solving is a primary function of left-brain activity; it is a form of applied creativity, and is not the focus of this book.

goes unnoticed by the left-brain because it is not in a form that this hemisphere recognizes.

Think of the right side of the brain as a vast store-house of sensory impressions. These memories are like one-celled creatures floating in a primordial soup, combining and recombining. At times they join to make an entirely new creature, one that is more than the sum of its parts—this synthesis gets sent to the left-brain where it becomes a gut feeling, a concept, or a creative inspiration.

The right side excels at deriving new combinations from seemingly unrelated perceptions, sensory input, and ungrounded data. This erratic, quick synthesis of thought and perception is creative activity, initiated from the right-brain.

It is apparent to me that many people are actually afraid of the thoughts coming from their creative right-brain, perhaps because that information is often random and appears to be out of context. They suspect the chaotic and unpredictable nature of right-brain input.

Jump in—the water is fine

In Chapter One, I defined creative immersion as one of the key aspects of creative behavior. Like anything else you learned as a child, the best way to learn to swim in the pond of sensual or intellectual immersion is to just jump in and do it.

Creative immersion is one of the most enjoyable experiences you can have as a human being; in losing your little self through focused attention on something outside yourself, you find something larger.

> *"We are kept out of the Garden by our own fear and desire in relation to what we think to be the goods of our life."—Joseph Campbell*

Les Fehmi and Jim Robbins call this "immersed attention" in their book *The Open-Focus Brain*: "When a creative artist or professional athlete effortlessly performs a well-learned behavior, or a dancer becomes so absorbed in the music and her movement that she loses a sense of self, that is immersed attention. Both diffuse and immersed attention are organized by the right hemisphere of the brain." [9]

Les Fehmi and Jim Robbins have observed that this kind of mental immersion is associated with a particular kind of synchronous brain wave activity that one may learn to achieve at will. The brain wave activity is a component of the particular attention that Les Fehmi has coined OPEN FOCUS.™ Athletes speak of a "runner's high," but this high is experienced by many creative individuals as well—it is not to be confused with an adrenaline rush.

9 Les Fehmi and Jim Robbins, *The Open-Focus Brain*, (Boston: Trumpeter Books 2007), 50
Open Focus™ is a registered trademark of Biofeedback Computers, Inc.

Artists who achieve immersed attention finds themselves seeking it again and again. It is a good addiction, because it means that we are seeking unimpeded access to the bliss of right-brain thinking—the state of rapturous consciousness that has been denied to most of us by our culture's exclusive focus on left-brain beta activity.

People who achieve Open Focus,™ attention (right-brain thinking), "notice positive changes in mood, tension, and anxiety—all widely reported effects of alpha…And long-term effects included improved memory, clearer thinking, and heightened creativity." [10]

Spend a few minutes everyday upside-down

As a child I liked to imagine what the world would be like from the perspective of a small ant or what it would be like to be as tall as a giraffe. I liked to imagine what it would be like to be able to fly like a bird and look down on the humans below. I remember laying on my back in the living room and contemplating the ceiling; imagining it was the floor, and the floor was the ceiling with all the furniture stuck on it upside-dwon. I used to fantasize what it would be like to flood the basement of our house to create an indoor swimming pool.

This simple upside-down thinking is the kind of activity we should revive if we are to access the inner child's mood of lightness and creativity. The only

10 Les Fehmi and Jim Robbins, *The Open-Focus Brain*, (Boston: Trumpeter Books 2007, 38

difference between the way an artist thinks and the way other people think is that the artist never stopped thinking these thoughts, and never gave up the wondrous, creative child in their soul.

3

BOTTOMS UP

Sit on your couch or overstuffed chair upside-down. If you can't do that, lay on the floor with your legs up on your couch. Wave your feet around in the air. Not only is this good for circulation, but it changes your point of view. Observe the undersides of things.

Think "upside-down" for a day

Allow for the idea that you are naturally creative. Start each day with an attitude of playfulness and receptivity. Once you have released the hard grip of the left-brain, it becomes possible to play with the world around you, especially with your own perceptions.

Try looking at everything upside down for a day. I have taken this idea literally—it's amazing how effective this simple exercise is at shaking up your mind. Upside-down thinking is key to many creative activities, including humor and conceptual art.

I conducted "scientific" experiments with the ingredients I found in my mother's kitchen. When I was about seven years old, I had the idea that waves could used for communication by watching the ripples of water in my bath. I rejected this idea soon after when I realized that radar and radio had already been invented.

Our literature is replete with metaphorical tales about the process of growing up in human society and about the subsequent loss of innocence, joy, and fun. The loss of the paradise of childhood is really the loss of our inner child; we gain knowledge and maturity at the expense of our innocence and connection. But while we need to mature into adults, it doesn't mean that we need to ever give up the inner child and its mission of play.

4

RECALL YOUR CHILD GENIUS

Take a moment, close your eyes, and allow yourself to remember your childhood thoughts. Did you have any notions that were dismissed by others? In retrospect, do you think any of your ideas had merit? How would you treat a child today who had ideas like these?

Transforming base metal into gold

As an artist, I consider it my job to be connected with my dreams and inner self. I am not afraid of the

realm of imagination; on the contrary, my dreams, my intuition, and my imagination are a rich source of information and material. I understand that even the most nightmarish dream has things to tell me, and this information can be mined for the gold that only the subconscious can produce.

5

REMEMBER YOUR DREAMS

Just before you drop off to sleep tonight, make a promise to yourself to remember your dreams. Place a dream diary by your bedside and vow to write your dreams down first thing in the morning. Give each dream a title, and write the contents of your dream on the right side of the notebook, leaving the left side blank for dream interpretation.

Nothing is negative when it can be used in art. The process itself takes the artist somewhere she could not have gone otherwise. An example of this is the artist who creates art out of trash, turning its value upside down and making art out of something that everyone else has dismissed as worthless.

This is the true magical nature of the artistic character—in the process of creating a valuable product

out of a negative experience, you transform yourself—
and possibly others—in the process.

Simply looking at something through the eyes of an
artist is enough to give a more balanced perspective to
even the most traumatic experience.

Gaining weightlessness

Maturity does not mean gravity. All creative people
play within their field of choice, whether they play with
science, or mathematical concepts; or with colors and
light in a painting, musical notes, movement, or words.

> *"Life is nothing but a dream but that dream
> is alive; you are creating that dream, and
> that dream working for you is pure magic."*
> —Don Miguel Ruiz

Even death can be seen in a different way when
looked at creatively. Simply shifting one's focus from
the microcosm— the death of a loved one—to the
macrocosm—the natural cycle of life and death—can
assuage grief, and allow oneself to come to terms with
feelings of loss. One of the known "functions" of art
is its power to transmute negative emotions or experi-
ences into art; the artist experiences the transmutation
and conveys it through his work to the viewer.

An artist may choose to simply express their feelings.
Giuseppe Verdi (1813-1901) mined his feelings of grief

51

to give us his exquisite *Requiem Mass*. The expression of an artist's feelings has resulted in some of the most poignant works of art and music ever produced. I use poetry for the purpose of expressing feelings; the process of putting my emotions down on paper liberates me from the gravity of my feelings.

As an artist you can choose any kind of creative activities to explore an issue, and thereby lighten your mood. In the process, the artist finds unsuspected resources that have nothing to do with what we normally associate with ourselves, with our conscious thoughts and identity.

How to properly integrate the two sides of the brain? The first step is to release the hard grip of the left-brain. The left-brain in the average adult is a true control freak, fearful of change or innovation.

The dysfunctional left-brain is convinced it needs to control everything because it needs to protect itself. The left side has to be convinced first that it's safe to let go, and then it has to be assured that the whole individual will benefit.

According to various philosophies, reality is created out of our thoughts; as we describe reality to ourselves we are actually creating it. We are not aware of the insidious way our internal dialog leads us to conclusions about our world—in time these unquestioned beliefs harden into absolute truths. Some of our thoughts are inherited from the people around us, while the rest is

self-generated. The internal dialog goes on incessantly in all of us.

The internal dialog in which we communally engage is what we come to believe is our social reality. The individual internal dialog is amplified when many people talk from the same point of view, as happens in consensual reality. These shared thoughts are called agreements by author Don Miguel Ruiz, and they amount to a belief system held by the individual or in common by the group.

Don Miguel Ruiz defines a *mitote* as a gathering or conference where people talk; the agreements arrived at within the *mitote* define the social system to which we all belong. We bring our thoughts into manifestation by talking about them, practicing them until they turn into beliefs or agreements. A kind of huge, unconscious feedback system, our thoughts and beliefs are finally justified in reality.

> *"Reality is merely an illusion, albeit a very persistent one."—Albert Einstein*

The exercises in this book are designed to work on more than one level, releasing the energetic, mental and emotional blockages to a creative life. An artist would take her internal dialog and use it in her art.

Exercises:

The theater of melodrama

Rewrite your internal dialog into a scene in a play; define each inner voice as an individual character. What would each character wear; what are their personality traits? Pretend you are an actor studying for a role, create a character study for each person in your dialog. Once you are clear on each character, play each part in turn.

This is your life

Film yourself in each role as defined above. "Interview" each voice/character in your journal on film. Be totally serious; set the camera up on a tripod, sit in a chair as each character and talk about your life as if you were this inner voice.

Create a comic opera

Set the most ridiculous/melodramatic lines in your mitote book to music or make your thoughts rhyme in a limerick. How does the thought you were thinking change when put into a new form? Do you see it differently?

Write yourself into a novel

Do you have a favorite genre in literature? Do you like science fiction, romance, biographies, or detective novels? Make an outline of a new

story in your favorite genre where each voice in your mitote is a character in your story. Professional writers determine the history, the thoughts/emotions, and the motives of each character they create. In the same way, each voice in your internal dialog exists because it has similar roots.

The play is the thing

You can mine your inner voices for a whole cast of characters in a play. Name each character; outline its characteristics and its motives. Figure out how each character relates to all the others in your play. Devise a plot where your inner voices have to interact with each other; perhaps they even evolve during the course of the play.

Pictures speak louder with words

Try making a diptych of the inner voices from your journal (a diptych is two—usually equally sized—paintings placed side by side). Represent the words of each of your inner voices with pictures. You don't have to be a visual artist to do this; make a collage from photos that you collect. Use the pictures from something else—a magazine for instance—to represent each participant in your inner dialog.

Each time you do something creative with your old thoughts you change the charge on them from negative to positive, and you make room in your mind for different, less limiting ones. Your thoughts are not you, and do not have to be your reality.

You get to choose what you want in your mental/physical environment, but first you have to know what is there. The process of creating art from personal issues is a great way to exhume these old thoughts and decide whether or not you want to keep them.

As we free the inner child we discover the rich resources that reside in all of us. The process is to first expose, then face mental and emotional issues. An artist uses her problems as content and inspiration, thus creating art as she heals and recreates herself. On the way she rediscovers the joy of creative play.

"Art is the cure for many a disease which has not been discovered yet"—anonymous

3

BODY & SOUL

Do you want to know the secret of eternal youth?

It seems every adult past the age of 25 is interested in knowing the secret of eternal youth. Are you prepared to hear it? I have taught large groups of people and have found very few adults can understand this secret —they thought I was joking (well, in a way I am). I like to use equations to make concepts easy to understand:

STRENGTH + FLEXIBILITY + {THE ABILITY TO BE SILLY} = ETERNAL YOUTH

This is all you will ever need. You can close this book now if you already understand my statement. Otherwise, please read on.

Referring to my equation, one needs control and discipline (expressed as mental and physical strength), flexibility and tolerance (in body and mind), and lack of self-importance (the ability to laugh at oneself, and to be generally silly), to achieve the feeling of youth.

I first used this formula on a group of adults I was coaching at my gym. First I had them do some pushups for strength and then roll back and forth in a tight ball on their backs for flexibility. I asked them when was the last time they had rolled on the floor in this way: most replied that it was when they were small children.

It's amazing how the mere act of rolling on your back brings back the same feeling of fun that you had as a child. I saw people lightening up and breaking into smiles. Then I had them lie on their stomachs and push up with their arms into the Cobra Yoga pose. They were facing the crowd of people on the exercise machines. While they held that position, I asked them if they wanted to know the secret of eternal youth, which, of course they did: "Strength plus flexibility and the ability to be silly is the secret to eternal youth."

As they lay there looking at the people on the machines who were looking at them, I told them to roll their eyes up into the tops of their heads and stick out their tongues way out and down towards their chins. It was amazing to me how many people could follow my instructions until it came time to appear silly. That is when their adult self took over, and kept them from

enjoying the moment. The real key to the secret of youth is the ability to escape the gravity of our thoughts and allow ourselves to be like children.

You may think that my recipe for eternal youth is outrageous, and of course, I am deliberately stating it in a way that will not only draw your attention, but I season it with humor to make it easier to remember. I use techniques commonly used in advertising to help build an idea in your mind, and help you retain this information. You might laugh at my use of marketing techniques to communicate a concept, but your laughter itself is useful. When people laugh, they relax their guard and open themselves to learning.

"Every human being is the author of his health or disease."—Buddha

Of course, I am not saying that we will never age or die if we practice the principles I am going to outline to you, just that we are more likely to enjoy our lives in health and youthful vigor for much longer. If you have a choice of living for twenty to thirty more years in disease, disability or pain, or of living those years in health and pleasure, which option would you choose? Would you make the necessary change in your habits to achieve that goal?

The newest thing in the health field is something called your "real age"—the age your body actually is,

not your chronological age. The idea is that people can be actually older or younger depending on their physical health. Two of the criteria used in their test to determine your actual age are the same as mine: strength and flexibility.

It is well known in the medical field that weight-bearing exercise affects the bone density of women, as much as or more than the intake of calcium. What happens is that the stress of bearing weight sends a message to the bones to build density, in order to handle the increase in stress.

6

CHECKING IN

Close your eyes, and run through your senses one by one. What does each one feel in this moment? Cycle through them, and then try to feel the inside of your body. What is your stomach telling you? What do your intestines, your muscles, and your heart have to say?

This is an example of a simple feedback loop which functions on all levels: mental, physical, emotional, and creative. The body is constantly building itself, re-creating itself, according to its perceived needs.

This process happens automatically without our conscious thought, but we can achieve conscious control as well; we just have to understand the synergy between our mental/emotional state and physical body.

> *"Mind undoubtedly is the mechanism of the past and it keeps us firmly bound to the past. Mind is the arch creator of bondages. Whatever we think about becomes our bondage."*
> —*Sudharta S.D., I Am All*

If you look at everything from an energetic standpoint, this becomes easier to understand. Energy is used on all planes of our existence. Energy drives our emotional and mental processes. Some activities build energy, while others deplete it. All human activity can be placed upon a spectrum of energy efficiency, with the most energy depleting activities at one end, and the most energy enhancing at the other.

The proper use of our energetic resources promotes health and happiness. When the physical, mental, emotional bodies are healthy, energy is well utilized. When the creative self is fully expressed, our energetic reserves actually build. A person with healthy energy appears young because youth is just an expression of abundant creative energy.

Disease indicates that the energetic system is breaking down; premature aging results from the

habitual draining of emotional energy. As adults, we are responsible for how we react to the circumstances of our lives. We may not be able to control outside events but we are all responsible for how we react to them. How we react is a direct result of how we *think* about those events.

> *"Man against God. Man against Nature. Nature against man. Nature against God. God against Nature—very funny religion!"*
> —old Zen philosopher commenting on Western philosophy to Joseph Campbell

Health is the body's natural state. The body has wisdom and a natural ability to heal. Like a pendulum that may swing but naturally seeks the center—the body can experience disease, but it has an amazing capacity to heal itself.

The problem is that we are instructed from a very young age to see the world in terms of diametrically opposed forces. We are taught that the universe is based upon conflict and competition: this translates to our very interior, our psychology and our bodies. In contrast, a more holistic philosophy sees connections, communication and synergy between systems.

Health is a sign of wholeness, the parts functioning in perfect harmony. Disease is a sign of disharmony. The body is a system that seeks wholeness and health. The complexities of a dysfunctional mind and emotional

body will eventually break down the harmony of that natural system, and lead to disease.

The study of the human body and health should be one of our natural priorities as adults. Our bodies are built to work well without our conscious control, but the mind and the emotions play a big part in whether it can do its job or not: the natural system of the physical body needs the support of the mind and the emotions.

The body is constantly sending our brain messages about what it needs and feeds us back information about our physical condition. These messages enable our physical systems to keep on functioning; we don't need to interpret these messages on a conscious level.

Other information, however, is very useful to us. This information often flies under the radar of our consciousness, and is delivered as intuitive cues.

"As I see it, every day you do one of two things: build heath or produce disease in yourself,"
—*Adelle Davis*

Reversing entropy

It is theorized in the scientific community that the normal life span of humans should be at least 120 years. It is not necessary to spend the last sixty of those years in disability and disease. It is now possible, given what we know about the synergetic partnership of the body, mind, and emotions, to enjoy a very long prime of life.

People have been taught to think of their bodies as a mechanical device, like a car. To continue the analogy: at the time of manufacture/birth, their car/body is a beautiful device with everything working in optimal condition.

After a few years things will start to go bad—there is an expected order to this; just review the manual in the glove compartment for the full story. Parts can be replaced but the car/body will eventually deteriorate and have to be eventually junked.

Unlike cars, our bodies have an extraordinary ability to rejuvenate. It is our thoughts, beliefs, and expectations that need to be revised or they will make us prematurely old and unhealthy.

Nurturing nature

Most people believe that what we are is due mostly to our genes, and the rest can be blamed on our upbringing. They think that their genes determine their physical future; what's more, they believe that their genes are on autopilot, and that there is nothing that they can do to change their fate.

What are the major contributing factors to the health or breakdown of the physical body? Nutrition, environment, and mental attitude: we can control at least two of these elements.

A human being can be visualized as several bodies in one: a physical body, an emotional body, a mental

body, and a creative body. They are like shells enclosing one another; like Russian dolls, one enclosed inside the other.

The body in the center is the physical body, the emotional body encloses it, next is the mental body; the top layer is the creative body. Each body is progressively more ethereal, with the dense physical body at the center and the outermost shell representing the pure energy of creative inspiration. This model is key to understanding how our thoughts can manifest in our physical body and in our material reality.

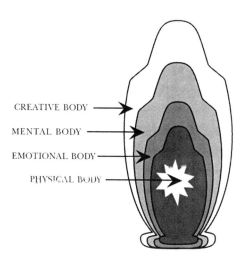

Another useful metaphor is to think of all of these bodies as a musical note: when the total person is healthy, the combination of notes from each body produces a

harmonic chord. Disease produces a discordant sound. When the physical, mental, emotional, and creative bodies are producing notes of harmony then the whole person is healthy.

> *"Every patient carries her or his own doctor inside."—Albert Schweitzer*

What thoughts did you have for breakfast?

The science of Epigenetics says that the regenerative cells in your body are controlled by your thoughts. Your mental state affects the cells in your body to such a degree that your thoughts can cause your physiological regeneration or decline.

In effect, you are constantly creating your body with your thoughts. Imagine it—we all have the power to bring our health under our conscious control.

There are two camps of people: the glass-is-half-full-people and the glass-is-half-empty-people. The half-empty people believe that everything is on an inevitable path of chaos, destruction, disease, and dissolution, while the half-full people think that everything is on a path of health and continual renewal. The attitude and physical health of each camp is a direct result of what they are telling themselves on a daily basis. What we tell ourselves is what we end up seeing in the world around us, and what we end up experiencing on the inside.

A civilized man resists his more primitive instincts in order to fit into society. It is a well-known fact that the repressed fight or flight response of the animal in nature is translated to stress in the physical body. A modern man cannot react according to his natural instinct, so the desire to fight or fly is repressed, at a great cost to the body.

6

RISE AND SHINE

When you wake up in the morning, spend a few minutes lying in bed, visualizing good health in every part of your body. Feel it flowing like an electrical current or pleasurable tickle throughout your body. Run it up and down a few times, stretch, and give thanks.

Stress has been determined to be the cause of many diseases. The real problem is not the stressful event, or even our thoughts about the event, but our *reaction* to our thoughts about the event.

It is the stress of our *resistance* to our own reactive thoughts that leads to disease in the body. Take away the thoughts and the resistance to the thoughts, and you have removed the blocks to good health. When you remove the resistance and stress, you allow the body to do its job.

We control our cells with our thoughts

Dr.. Bruce Lipton has done extensive research on cellular life and its relationship to the mind. He claims that the cell membrane passes information about the environment to the genes. The genes control cellular mechanisms which provide for the cell's survival.

However, it is the brain that evaluates whether the environment is safe or not. If safe, it tells the cells to focus on growth, if unsafe, the energy of the body is conserved for survival functions: the cells stop growing. However, the body needs to maintain normal cellular growth in order to maintain health.

Dr.. Bruce Lipton: "...when confronted by stress, cells adopt a defensive protection posture. When that happens, the body's energy resources, normally used to sustain growth, are diverted to systems that provide protection. The result is that growth processes are restricted or suspended in a stressed system."[1]

Our perceptions and beliefs about our environment send messages to the cells in our bodies; when we change our beliefs we are actually reprogramming our cells. So, according to Epigenetics, our physical body is created by our thoughts.

Pretty sobering, huh? But there is more to creative manifestation than what happens in our bodies.

We can create all kinds of things—a new job, a healthy body, a baby, a relationship, and all kinds of

1 Meryl Ann Butler ,*A Romp Through The Quantum Field with Gregg Braden and Dr.. Bruce Lipton*, Awareness Magazine November / December 2006, 21

things, but sometimes we feel stuck, and continue to create the same thing over and over again. This is because our thoughts and our perceptions are being played in our minds over and over again. We have no room for any original thought; in such a closed state we cannot create anything new.

Running to stay in the same place

In Chapter Two, I spoke of the alpha waves and about how entering a phase-synchronous alpha state is felt as a kind of rapture where time doesn't exist. Beta wave pattern, or left-brain activity, also has several levels or speeds.

High phase beta brain waves evolved as a survival technique to deal with high stress emergencies in the natural world. In the modern world, narrow-objective focus became a way to accomplish a great deal in a short amount of time.

However, as we have seen, the stress of constant narrow-focus is not good for our health, and not conducive to creative thinking. The stress caused by sustained high phase beta waves makes us feel as if time is going faster and faster, and gives us the impression that we can never keep up with change.

Just at this moment, somehow or other, they began to run...“Now! Now!” cried the Queen. “Faster! Faster!” And they went so fast that at

last they seemed to skim through the air, hardly touching the ground with their feet, till suddenly, just as Alice was getting quite exhausted, they stopped, and she found herself sitting on the ground, breathless and giddy.

The Queen propped her up against a tree and said kindly, "You may rest a little now."

Alice looked round her in great surprise. "Why, I do believe we've been under this tree the whole time! Everything's just as it was!"

"Of course it is," said the Queen: "what would you have it?"

Well, in our country," said Alice, still panting a little, "you'd generally get to somewhere else—if you ran very fast for a long time as we've been doing."

"A slow sort of country!" said the Queen. "Now, here, you see, it takes all the running you can do, to keep in the same place. If you want to get somewhere else, you must run at least twice as fast as that!" [2]

2 Lewis Carroll, *Alice's Adventures in Wonderland and Through the Looking Glass* (New York: Penguin Group, 2003),145

A case of myopia

Society has groomed all of us since childhood in narrow-objective focus. We never question it, but it saps a lot of our energy. In a world of exploding information, where we often are expected to do two or more jobs at twice the speed, we are in a constant state of stress, and this takes an enormous toll on our bodies.

"Narrow focus occurs when our well-being is threatened—a reflexive response to fearful situations" [3] As our eyes are naturally our primary sense linked to our survival, we often experience emotional stress there. We use our eyes for narrow-focus activities that are predominant in our daily lives: such as reading, and working in front of computer screens.

Change your thoughts, and change your world

To get to the point where we can change our perception of reality, it is first important to learn to clear our minds from old thoughts. One way to clean our mental body is to meditate, however, many find meditation difficult or time-consuming.

The purpose of most meditative practices is to experience the state of *no thought*. Another way to get into this state is to dive fully into one's senses, through intellectual or sensual appreciation.

This is a shortcut to the most extraordinary experience. Once the mind is softly focused on

3 Les Fehmi and Jim Robbins, *The Open-Focus Brain*, (Boston: Trumpeter Books 2007. 19

something, narrow-focus beta waves stop, and formerly inconceivable creative ideas can flow. The narrow-focus brain waves of normal life serve as a dam—once that dam is removed the natural flow of creativity is released.

> "The creation of something new is not accomplished by the intellect but by the play instinct acting from inner necessity. The creative mind plays with the objects it loves."—Carl Jung

Practice sensuality

Many people confuse the words sensual and sexual. The definition of sensual means, "pertaining to the senses or physical sensation." Many people have been taught to believe that sensuality is a bad thing, and that the pleasure of the body should be avoided.

Fear of the body's capacity for pleasure is one of the reasons that we have so much mental, physical and emotional disorders today. Disease comes from mental and emotional repression and resistance; we have inherited the underlying belief that sensuality is wrong. We think that to indulge ourselves in the pleasure of our senses is unhealthy and irresponsible.

On the contrary, it is healthy and responsible to take care of one's body and allow it to feel pleasure and experience the world though the portals of our senses. Have you ever noticed how a tiny baby has to put everything into his mouth? No one in his right mind

would punish the baby for trying to taste his world—they would only take away what is not good for him. We are on this earth to feel, taste, smell, see, and touch as much as we can; we connect to the world through our marvelous bodies.

Health exists first in the mind. If you want to be healthier, visualize health in your body, visualize how all the organs and the cells naturally cooperate in the daily functioning of your body.

> "In this mindful awareness, the mind truly becomes a guest house in which all visitors, as uncertain as the guest list might be, are invited in and welcomed at the table."
> —Daniel J. Siegel, M.D

Cultivate the attitude that each and every day your health is getting better and your body is growing more beautiful, powerful and youthful. If this is too big a step, then find another phrase that you can believe and that makes your feel good about your body.

If you are having problems with your weight, don't focus on your current body image, but instead on how your body feels inside. Learn to first accept and then appreciate your body as it is right now. Shift focus from your mind to your senses; once there, it becomes easier to change your thoughts and the habits that your thoughts support.

One of the habits I like to cultivate is to awake naturally in the morning and feel the luxurious heaviness in my limbs. My body is happy and relaxed; it is literally purring like a cat; enjoying the sheer pleasure of being alive.

Track your thoughts

When you find yourself thinking of something that is not in your immediate environment, try gently focusing your attention on whatever is right in front of you. If you are washing the dishes, and find your mind wandering, simply focus on the feeling of the water on your hands and the task of washing each dish.

This practice can be an enormous relief when you find your thoughts going in circles. The mind has a way of cycling through thoughts: "squirrel-caging," it is often called. Most of our habitual thoughts are self-limiting. Ninety-nine percent of what we are thinking we thought the day before, and most probably the day before that.

Exercises:

Don't eat the paint

Really explore the sensual aspects of making art: the textures, the colors, the smell, even the sound of your brush as it sweeps the canvas. Slow down to a snail's pace as you explore the process from the aspect of your senses.

All I hear is white noise

Make sounds with whatever is at hand. Explore the textures and colors of the sounds and perceive the noise you are making with every sense. Hear it first as just noise and then allow yourself to hear it as a musical piece. Listen to how the environment is participating in your composition: voices talking in the house, dogs barking in the distance, cars passing in the street, and so on.

Ransom note

Make poetry out of a newspaper article, headlines, a billboard, or email that you have received. Mix and mingle the words into new stanzas that no longer make the same sense or make total nonsense. Speak your new piece, feel the words become unfamiliar in your mouth. Revel in the feeling of the hard consonants and the fullness of the vowels on your tongue.

The purpose of these exercises is to practice the feeling of being in your body rather than being in your mind. The techniques described above employ what the Buddhists call "mindfulness"—a state in which you make yourself more aware by focusing your thoughts on the simple present.

The purpose of mindfulness is to break the habit of mind-chatter, but we can go further and break the habit

of limiting thoughts. In fact, to access the creative state of receptivity, it is best not to be thinking at all.

As you are in your body more and more, and as you appreciate the little things in your life, time will start to slow down, and you will start to feel relaxed. The mind starts to release the low vibration of anxiety that prevents total health. Only when the body is healthy and the mind is open and relaxed can our full creative nature finally emerge.

A Zen master, Nan-in, from the Meiji era, poured tea for his visitor, a university professor who wanted to learn about Zen. He filled his guest's cup and kept on pouring. When the professor observed that the cup, being overfull, wasn't capable of receiving more tea, Nan-in said, "Like this cup, you are full of your own opinions and speculations. How can I show you Zen unless you first empty your cup?"

4

SHAKING THE TREE

If a tree falls in the forest...

We are altering our physical bodies on a cellular level with our thoughts. It is our *perception* of our environment, not the actual environment that is affecting our bodies.

So how does perception happen? In essence, reality is just a thought in our brain. This is because the human brain cannot perceive anything directly; it has to think about everything that the senses experience.

The brain is a highly effective filtration device. The network of cells that performs this function is called the Reticular Activating System or R.A.S. for short.

77

The R.A.S. lets in only data that meets at least one of the following criteria: data that is important to your survival, data that has novelty value, or data that has high emotional content.

> "We have found a strange footprint on the shores of the unknown. We have devised profound theories, one after another, to account for its origins. At last, we have succeeded in reconstructing the creature that made the footprint. And lo! It is our own."
> —Sir Arthur Eddington

If the brain did not filter out most of the information it receives we would go mad. We would not be capable of making decisions important to our survival. So the train rushing at our car stuck on the tracks would be of the same level of importance as the texture on the dashboard in front of us.

In a way, the R.A.S. is a kind of robotic artist who paints a picture of your environment every moment you are alive: the R.A.S. classifies most of the data it receives as unimportant, and paints it into the background, while important information is thrust into the central foreground position.

Sometimes what is in the background comes to the foreground. For example, you are standing on the

sidewalk, and there is a lot of traffic noise around you. You are paying attention to a dog you are petting.

Suddenly some of the traffic noise gets very loud; you become alarmed because the R.A.S. assumes a possible threat to your survival, and forces the background traffic noise into the foreground of your consciousness.

You look up to see a truck bearing down on a small child playing in the street. The R.A.S. is triggered again, this time because of your emotional response. Now everything else—the street, the dog, and your problems at work —fades into the background as you rush to save the child.

> *"The problem is never how to get new, innovative thoughts into your mind, but how to get old ones out. Every mind is a building filled with archaic furniture. Clean out a corner of your mind and creativity will instantly fill it." — Dee Hock*

As stated before, the brain cannot directly perceive anything: the senses deliver impulses to the brain that it receives and classifies. In order to properly process that information it has to compare the new information to old information. It puts new information in perspective by recalling what is not present: our history, our beliefs, our thoughts, and even our fantasies. All new information is classified even before we are aware of it.

In his book, *An Anthropologist On Mars*, Dr. Oliver Sacks recounts a case history of a middle-aged man who had his sight restored to him after a near lifetime of blindness. Unfortunately, help arrived too late: the novel experience of sight was chaotic and nightmarish and hallucinogenic in nature.

What happened was that his brain was not able to process the sudden onslaught of raw information that he received, because he had no frame of reference. He didn't have a brain adapted through experience to the phenomenon of sight. He couldn't perceive what his eyes saw, because his brain couldn't filter and classify the unfamiliar information.

In other words, he couldn't see because his brain couldn't think about what he saw. Or, we can make the creative reduction and say it is the brain that sees, not the eyes.

At the speed of thought

Science has discovered that the brain cannot tell a fantasy from a sensory perception. This is because everything in the brain is merely a thought.

Imagination or memory is just as powerful as "reality," because, to the brain, it *is* reality. This is an indication of just how powerful our thoughts can be. They can inform us, delude us, or create our reality.

What is really interesting is what happens when a thought becomes a belief. I have two simple formulas, which show this process:

THOUGHT + PRACTICE = A BELIEF

BELIEF + PRACTICE = REALITY

This is to say that if we think a thought over and over again it becomes a belief. Believe something long enough, it starts to become your reality. As you practice your belief, you will start to notice that there is more and more evidence in your world to support your belief. You are manifesting your thoughts!

> *A fifteenth-century student asked the famous Zen master Ikkyu to define the essence of enlightenment. The master wrote in the sand at their feet a single word: "Attention." The student wanted him to elaborate. Ikkyu wrote, "Attention. Attention. Attention."*

Part of this process is simply the focus you are exerting upon select elements in your environment; but in the final analysis, the brain can only perceive what it is focused on—your perception is your belief system *and* your reality. Simply believing something strongly is enough to make it happen more.

The threshold level of the R.A.S. is affected by one's beliefs. If you believe that you are unlucky, for instance, you wouldn't be able to see an opportunity even if it hit you in the face—or, if you could see it, you would believe it was too good to be true.

Earlier I defined one of the elements of creativity as an ability to shift focus: this skill is necessary if you are to create anything new. The artist understands that a shift in focus creates not just a new subject but also a whole new environment. It enables change, as it creates the mental and emotional space for the change to occur.

> *Life's but a walking shadow, a poor player, that*
> *struts and frets his hour upon the stage and then*
> *is heard no more; it is a tale told by an idiot, full*
> *of sound and fury, signifying nothing.*
> *—William Shakespeare, Macbeth*

Why don't you act your age?

Everything that people do is really an act. We are acting out our thoughts everyday, and they become the basis for our reality. It is insane to believe that everything that we are thinking is real. However, this is how we are made—we cannot perceive without thinking, so we cannot stop thinking. We are like magicians who have come to believe in our own staged illusions. We have a hard time not believing that what we think may just be a thought and not real.

Acting is an art in which one can choose one's role. Few people know that we are acting in life as well.

The role you play—student, mother, boss, or son is not your identity any more than a role is an actor's identity. In a way, we are all nothing more than a point of view.

7

CHANGE THE SUBJECT

Try this well-known artist trick: form a camera "lens" with your thumb and your forefinger and look through it using one eye. Notice what you have in the foreground and in the background. Move your hand to change subject matter, shift focus from the foreground object to the background and visa versa.

We believe our own dramas, and thus limit ourselves cruelly. "Why don't you act your age?" people often ask without realizing the literal truth behind the phrase—everything we do is an act that we have started to believe.

The only sane conclusion is to realize that we are all acting and thus can choose the reality in which we live. How can a creative person use this knowledge?

Cropping and focus are two of the major tools of the conscious creative: the difference between an average person and an artist is that the artist is conscious of the act of focusing and has chosen the focal point. In fact, focus and cropping are one of the major tools of the visual arts; the artist is practicing this skill all the time.

> *"We all know that art is not truth. Art is a lie that makes us realize the truth."—Pablo Picasso*

If you shift what is in your view or in your focus, you change the subject, thereby changing the entire picture. When we realize that everything we do is initially just an act, we have the ability to change the act, change the focus and change ourselves.

Try to change focus with your creative work. Think of how you can apply a small change in focus, and effect a large change in the final piece. If you are a humorist, you can force a change in the audience's focus and provoke laughter. Watch the comic masters to see how they constantly play with the viewpoint and perceptions of the audience.

Comic Rowan Atkinson as Mr. Bean demonstrates his unusual evening routine as he pulls down the covers, slips into bed, pulls a gun from his bedside table and shoots out the overhead light. An artist begins by playing with the simple element of focus, and ends up

playing with beliefs, ideas, and perception. The artist who understands this principle develops a mind that is fluid and flexible.

Truth is just one point on the circumference of all possible thought

Psychiatrist David Shainberg and quantum physicist David Bohm believe that our thoughts are vortices in the river of our energy bodies. They tell us that a vortex is a particularly stable phenomenon; the stability of this energy configuration explains how our attitudes and beliefs can be so resistant to change:

"A particularly powerful vortex can dominate our behavior and inhibit our ability to assimilate new ideas and information. It can cause us to become repetitious, create blockages in the creative flow of our consciousness, keep us from seeing the wholeness of ourselves, and make us feel disconnected from our species...when we allow the same vortices to take form repeatedly he (psychiatrist David Shainberg) feels we are erecting a barrier between ourselves and the endless positive and novel interactions we could be having with this infinite source of all being." [1]

A person with left-brain dominance will often resist the idea that the reality they see may be based upon their belief system. For them truth is a self-evident absolute; they forget that their truth might have started as a

1 Michael Talbot, *The Holographic Universe* (New York: HarperCollins Publishers, 1991),73

thought in someone's mind. The thought has become an apparent truth through repetition and agreement.

Those who believed that the world was flat had plenty of agreement from everyone around them, in fact, no one in history had ever questioned the basis of this belief, nor requested proof of it.

> *"The world of science lives fairly comfortably with paradox. We know that light is a wave, and also that light is a particle. The discoveries made in the infinitely small world of particle physics indicate randomness and chance, and I do not find it any more difficult to live with the paradox of a universe of randomness and chance and a universe of pattern and purpose than I do with light as a wave and light as a particle. Living with contradiction is nothing new to the human being."—Madeleine L'Engle*

The artist questions everything, he nurtures a state of inquiry, and explores everything in his environment. That is the value of the artist—he is a scout on the frontier of thought.

From the standpoint of quantum physics, what is there in front of us is only energy—or a bunch of particles, depending upon your point of view. Physicists conducting experiments at the quantum level discovered that the subatomic object they were looking

at became either a wave or a particle, depending on their expectations.

When Niels Bohr stated, "Anyone who is not shocked by quantum theory has not understood a single word," he meant that the left-brain finds these ideas counter-intuitive. The right-brain simply finds them interesting. In a way that is not understood by the logical, left-brain, quantum theory makes sense to its hemispheric partner on the other side.

This is because the right-brain actually lives a different reality than the left-brain; a realm of possibility, adventure and exploration, while the left-brain lives in a world of dry history and absolute truths. The right-brain looks eagerly forward into an unknown and uncertain future of exciting possibilities, while the left-brain looks backward into the history of its own thoughts.

So reality is based upon one's beliefs; or as stated above, truth is just one point of view, subject to one's thoughts and perceptions.

The Cheshire Cat in *Alice's Adventures in Wonderland* explained this quite well:

> *"In that direction," the Cat said, waving its right paw round, "lives a Hatter: and in that direction," waving the other paw, "lives a March Hare. Visit either you like: they're both mad."*

"But I don't want to go among mad people," Alice remarked.

"Oh, you can't help that," said the Cat: "We're all mad here. I'm mad. You're mad."

"How do you know I'm mad?" said Alice.
"You must be," said the Cat, "or you wouldn't have come here."

Alice didn't think that proved it at all: however she went on. "And how do you know that you're mad?"

"To begin with," said the Cat, "a dog's not mad. You grant that?"

"I suppose so," said Alice

"Well, then," the Cat went on, "you see a dog growls when it's angry, and wags its tail when it's pleased. Now I growl when I'm pleased, and wag my tail when I'm angry. Therefore I'm mad." [2]

2 Lewis Carroll, *Alice's Adventures in Wonderland and Through the Looking Glass* (New York: Penguin Group, 2003), 56

The Cheshire Cat is right: from someone else's standpoint what is normal to us could be considered eccentric, mad, or just plain weird.

Truth is stranger than fiction

If truth can be such a flexible thing—as we see in science when things that were once accepted as true are disproved—the only sane thing would be to understand that nothing is absolutely true.

It may be that we have to accept the possibility that, as beings that like to make things up and then forget that we have done so, we may have made up the idea of truth, and perhaps the only truth is that everything is actually a lie.

You may find my statement ridiculous, but it is the role of the artist to question everything, including what everyone else accepts as truth and reality itself. A conscious creative needs no authority outside himself.

All systems are closed systems

Through the influence of quantum physics, scientists are getting close to an existential truth: that any reality is just a closed system with related elements. In other words, the system of classical physics holds true for the elements of a physical nature. Inside the system of physics, we can certainly attest to the truth of physical reality.

However, the validity of that system begins to fall apart once we get to the subatomic level of reality: the rules of physics cannot be imported into the system of quantum physics or vise versa. Within quantum physics energy works in a way that defies the rules of physical reality, even down to the existence of time and space. Particles can be waves, and the same particle or wave can be in two places at once.

Conversely, the laws of quantum physics don't make sense inside the system of standard physics: Objects cannot be in two places at once, and beliefs do not supplant empirical evidence.

The truth is the one that floats

The artist knows that any system has an internal structure and within that system everything is right and valid, otherwise it wouldn't be there for long. It would be repelled the way a virus is expelled from the body. It is only when you exit that world and view it from the outside that elements in that world are seen as foreign.

Perhaps it is better to say that what is untrue is only the item's incompatibility with the system in which it is embedded. The artist builds a structure or system and populates it with elements that make sense within that system.

The choice of the items is based upon the internal logic of the system. In other words, in a well-constructed piece there is agreement within the elements of the

system—they belong together. The viewer/listener senses this and does something quintessentially human: he perceives beauty.

> *I have one major rule: everybody is right. More specifically, everybody, including me, has some important pieces of the truth, and all of those pieces need to be honored, cherished, and included in a more gracious, spacious, and compassionate embrace.—Ken Wilber*

Aesthetics may be just another pattern

The discernment of an underlying structure is at the base of what we often call "beautiful." We see a face with symmetry and balance as attractive; we prefer an orderly room as opposed to a disorderly one; most of us find dissonant chords ugly. When we discover structure in what we formerly perceived as chaotic, we experience an aesthetic epiphany.

We are compelled by our nature to look for order and meaning in everything. Humans love patterns. We search for structure in everything; scientists have gone so far to define a "chaos theory"—assigning a theoretical pattern to how chaos forms.

Structure in a system is analogous to the skeleton that supports the body and allows it to move. As grammar is the medium for language, the structure of any piece allows the artist to communicate.

Without the order of the underlying structure, the viewer would not be able to understand that there is even a communication to read, for the form would appear to be chaotic. The function of the left-brain is to assist the artist in making sure that the elements in the piece belong to the structure. Analytical thinking and organization is one of the key functions that the left-brain performs.

There is an accepted structure to everything in human culture. This need for structure operates on a subconscious level in all of us. It includes such things as morality, laws, ethics. On a physical level it defines the streets, buildings, and communication systems. Most people have relegated these systems to the background; they are generally unconscious of the systems in which they live, and of the power of their environment.

8

THE MEDIUM IS THE MESSAGE

Next time you are working, ask yourself this most basic of questions: "What would happen if I change the format, size, structure, or medium; how would this decision affect the impact of this piece?"

The first decision that an artist has to make is the system she is going to use. Often, this has become a given, and the artist is no longer aware of this as a

decision. For example, she may have chosen early on to work in computer graphics or in sculpture.

Like laying the cornerstone of a building, everything else is built and dependent upon this initial decision. A composer uses structure within music, which is most often made within established musical systems, called rhythms and musical keys. Similarly, a painter will use the structure of the rectangle of canvas and create within that system.

Once the structure is established, it becomes effectively the "background" of the piece. It provides the matrix in which the middle ground and foreground elements reside. No matter the medium that you use, the very first decision that you make is what system you are going to use. Some of the most innovative works of art began from a shift in systems.

> *"Symmetry is static—that is to say, inconspicuous"—William Addison Dwiggins*

Changing the structure of your work can have enormous effects on the final piece: it is as if you changed the blueprint of a building. If you are a painter and have been working on a canvas, perhaps the shift is as subtle as changing to working on wood panels—or as radical as making the entire room your canvas.

If you are a musician, you may choose to work with totally different harmonics. If your medium is

theater, perhaps you choose to take your work off the commercial stage and put your impromptu performance in a public place, as an improvisational group once did unannounced on the subways of New York City.

Tracks in the snow

As an artist chooses the structure for his art, so we all can choose the beliefs that form the structure of our reality.

All beliefs start with a thought; that thought had its origin in an event that we translated in a particular way. You can track the emotions back to the originating thought; from that perspective you will be able to perceive the structure of your belief system.

Our beliefs are so integrated into our lives that sometimes we do not even know what they are. The easiest way to uncover one's unconscious beliefs is to track them. In the same way that a hunter examines the tracks of an animal in the forest to learn more about the animal, so you can track your habits to discover the originating thought behind a belief.

Visualize this process as beads on a string extending into the past: each bead represents a thought, an experience, or a belief. Imagine this string with the bead on the farthest right as representing the belief you have today about—let's say—that all cats are mean and unpredictable.

As you go backwards to the next bead on the string you are going backwards in time. The next bead is the recent event that triggered the belief—a cat hissed at you. As you go back to the previous bead, you can see that even before you approached the cat, you had fear.

> "We seldom realize, for example, that our most private thoughts and emotions are not actually our own. For we think in terms of languages and images which we did not invent, but which were given to us by our society. We copy emotional reactions from our parents...Society is our extended mind and body."—Alan Watts

Skipping a few beads back you recall the event that triggered the initial thought; you were a small child and grabbed your neighbors cat after they told you she was afraid of people. She scratched you.

Now going forward a bit, you see your emotions of surprise, disappointment and pain. You discover at the next bead that you developed the certainty that all cats must be unpredictable and mean. Every time you see a cat now, your emotions of fear and distrust are automatically re-triggered, even though you may not consciously recall the initial event or your part in it. This is how our beliefs work to provide the unconscious structure in our lives:

1. we all have beliefs
2. beliefs are often inherited from others
3. all beliefs stem from an originating thought
4. a first event triggered the originating thought
5. similar events trigger the thought again
6. with repetition a thought becomes a belief
7. beliefs form the background of our lives
8. we can choose our thoughts and beliefs
9. our thoughts create our reality

Searching for hidden treasure

When you can see the pattern of each belief, you can unravel them. Like an archaeologist bent on discovering the lives of the citizens of an ancient city through their artifacts, an artist digs into her own psyche to find a treasure-trove of thoughts and emotions.

Our thoughts are so powerful that they not only create our reality, but our identity. Dr.. Oliver Sacks, one of my personal heroes, says it beautifully, "If we wish to know about a man, we ask 'what is his story—his real, inmost story?'—for each of us is a biography, a story. Each of us is a singular narrative, which is constructed, continually, unconsciously, by, through, and in us— through our perceptions, or feelings, our thoughts, our actions; and, not least, our discourse, our spoken narrations." [3]

3 Dr.. Oliver Sacks, *The Man Who Mistook His Wife For A Hat*, (New York, Summit Books, 1985), 105

Many of the thoughts and beliefs that we hold and practice are not even ours. The thoughts of our parents, siblings, teachers, society, nation, and race inhabit our heads. A crowd of judgments lives inside each of us.

It's an incessant chattering of different voices and personalities, each with their own history and agendas. No wonder we are all mad, like the Cheshire Cat says. Anyone could go insane with this many voices in their heads speaking at the same time.

9

CHAIN REACTION

Track your thoughts and beliefs back in time. Examine a pet peeve. What emotion do you experience? What thought engendered the emotion? What event triggered the thought? What was the first time you remember this happening to you?

Me, myself, and I

How many of us identify with our thoughts? If someone were to ask you who you are, how would you respond? Are you aware what thoughts form the basis of your identity?

Most of us are not aware that we are living the thoughts and beliefs of an entire lifetime; what's more, we have inherited the thoughts and beliefs of others

around us. Our personal preferences and habits define our identity, while our reality is composed of our perceptual bias and beliefs.

A creative person questions everything; that especially applies to systems, structures and beliefs. If you are not yet convinced of the power of your mind, here is a terrible, but catalyzing idea: imagine that you may be condemned to thinking the same limiting thoughts for years unless you make an effort to change. Life can be heaven or hell, depending, to a great degree upon your attitude, and your willingness to change.

I am this

Our ideas about the world and ourselves are built out of our internal dialog. A lot of the internal dialog is built out of limiting thoughts that may not even be ours. Try taking your preferences and habits out for a walk today: choose a different route home, different colors to wear, or eat different foods. Your preferences are not set in stone—they are not you. Your preferences can change, and so can you.

Exercises:

Truth is stranger than fiction

Construct a detective novel using clues from your existence to generate a portrait of this mystery person: you. Design a protagonist made

of your habits, quirks and preferences, place this character in situations and environments that allow him to express his identity.

The scene of the crime
Collect clues to yourself; make a list of your habits, cut out pictures of your favorite things, put them in a box, and photograph them. Make an outline of your body on the floor and place the clues inside the outline; photograph the ensemble. Do you have enough clues to reconstruct the personality of this person? Is this collection of thoughts and beliefs you? Can you imagine yourself without these things?

I am that
How do you identify yourself? Most of us seem to be a mere collection of personal preferences and habitual responses. Try taking the other side in an argument, or opposite stand on any issue in your mind. Try to imagine yourself standing on the other side for a while.

The scene of the crime, version 2
Using the same techniques as in Version 1 above: Make another outline and fill it with the elements that define who you want to be, or who you wanted to be as a child. Or make an image of who you think other people want you to be.

Arguing with yourself

Recall a conflict you have had in the recent past. Script it and film yourself playing both parts: wear the clothes and assume the mannerisms of the other person when playing them. The more elaborately you stage this, the more effective it will be as an exercise, and as a work of art.

Themes of identity, ego, and point of view are common in contemporary art. These exercises allow you to see yourself from the outside.

We have to use our thoughts and beliefs to make sense of the apparent chaos that surrounds us; so why not choose these thoughts and beliefs from now on? Use your belief system for you instead of against you.

Eventually, you may find that you don't need many beliefs at all; at that point the world becomes a truly magical place: I like to call this place *creative freedom*.

The quantum magic of the integrated brain is incredible: our perception of reality is, to a large part, under our control. We could say that we are creating our reality as we think about it.

Whether you dream of making a work of art, a relationship, a business, or a new life, you are constantly creating. What are our dreams but thoughts in our heads? We are the ultimate dreamers—we dream our lives, our reality.

"Most men lead lives of quiet desperation and go to the grave with the song still in them."—Henry David Thoreau

5

NAVIGATING A SEA OF EMOTIONS

All human emotion may be distilled down to just two basic ones: love and fear. Imagine a spectrum with fear on one end and love on the other. The emotion of fear causes closure, resistance, and distance. The emotion of love causes openness, relaxation, and a feeling of intimacy and connection. All the nuances of human emotion may be placed on this scale, with fear and closure at one end, and love and openness at the other end of the spectrum.

The monster that lives at the edge of darkness

The state of fear or anxiety shuts down the higher functions of the brain. Dr. Bruce Lipton states, "In a state of fear, stress hormones change the flow of blood in the brain. Under normal, healthy situations, blood flow in the brain is preferentially focused in

the forebrain, the site of conscious control. However, in stress, the forebrain blood vessels constrict, forcing the blood to the hindbrain, the center of subconscious reflex control. Simply, in fear mode, we become more reactive and less intelligent."[1]

Resistance is futile

Most of us do not know the first thing about our own emotional landscape, the underpinnings of our mental/emotional being, and the relationship of the whole to our health. It is in the clear observation of our own mental/emotional reactions that one can begin to trace the path of habitual thinking. Only then does one have a chance for change.

> *"All that we are is the result of what we have thought. If a man speaks or acts with an evil thought, pain follows him. If a man speaks or acts with a pure thought, happiness follows him, like a shadow that never leaves him."—Buddha*

Let's take as an example that you just looked in the mirror and had the thought that you look old and tired. What is the first reaction that most of us have to any unwanted thought and its accompanying emotion? It is resistance: we become defensive to our own thought.

1 Gregg Braden and Dr.. Bruce Lipton in an interview with Meryl Ann Butler, *A Romp Through The Quantum Field with Gregg Braden and Dr.. Bruce Lipton*, Awareness Magazine , November / December, 2006, 21

As the Borg character said in *Star Trek, The Next Generation*, "Resistance is futile." Resistance to our own thoughts—our perceived reality—does not help us. The only thing that helps is to observe our resistance. The first step to changing ourselves is to find out which of our thoughts is causing us a negative reaction. The bigger the reaction, the more that thought needs work.

> *"I have come to believe that the whole world is an enigma, a harmless enigma that is made terrible by our own mad attempt to interpret it as though it had an underlying truth."*—Umberto Eco

There are no negative or positive thoughts, only those that work for us and those that work against us. It is up to the individual to discover which thoughts work for them at this time in their life. This can change: for instance, at this time, accessing thoughts of anger may serve you, at another point the same emotionally charged thought may no longer be useful.

Eventually, you can get to the point where you look at each reactive thought you uncover as a kind of hidden treasure. You can actually get to the point where you see emotionally charged thoughts as gifts to help you on your path to conscious change.

In fact, in changing your general outlook —from resisting your negative thoughts to actually looking for them —you are effectively switching the emotional

charge on the thought from "negative" to "positive," or at least to neutral. As a result, the thought has lost its power over you. You have successfully used your creativity to change your emotional reality.

Negative emotions are just trapped energy, displaced from your natural energetic centers. As such, they can drain your health, because the human being is a closed energetic unit. We have only so much energy; when it is displaced from the centers of energy in our bodies, we can experience mental/emotional distress, and eventually disease.

> *"The foundation of all mental illness is the unwillingness to experience legitimate suffering."—Carl Jung*

At first it may be difficult to achieve detachment to your thoughts. It is important to know that your thoughts are not you. You are a being with free will. Most people think that this means that we can choose our acts, but since all action stems from an initiating thought, it really means that you have the freedom to choose your thoughts. You are using thoughts to describe the world to yourself, thus creating the reality in which you live. Only by having a choice of what to think can you choose a different thought, and a different course of action.

Emotion as a tool for transformation

Why do we have emotions? Are they useful? What is the role that emotions have in the health and functioning of the mind/body system? Here is a creative reduction: what is an emotion but a strongly charged thought?

Remember the diagram of the healthy human body that I described in Chapter Three?

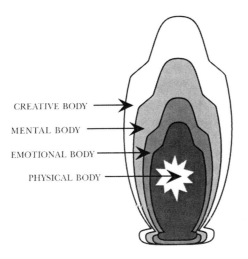

CREATIVE BODY
MENTAL BODY
EMOTIONAL BODY
PHYSICAL BODY

So, using my diagram of the four bodies that make up a human being, the creative process is as follows: inspiration from the ethereal creative body becomes a thought when it passes through the mental body; the resultant thought is charged with an emotion as it passes through the emotional body; the charged thought coalesces into matter, becoming physical reality.

Notice that the position of the emotional body is the one nearest to the physical body at the center. Its role is to coalesce your creative thoughts from the ethereal creative body into the density of physical form. Emotions are extremely powerful—they can bring us health, happiness, or success in any endeavor; emotions are the most powerful tools in our creative toolbox.

"There is nothing either good or bad but thinking makes it so."—Hamlet, Shakespeare

Emotions are the essential catalyst in the alchemical process of making your thoughts real. You may think that you have to work to manifest your thoughts, but the process is happening all the time without your conscious control. Not many people realize that their emotional life is determining their physical reality.

Marketing experts say that there are two types of consumers: impulsive consumers who make impetuous emotional decisions, and rational consumers who base decisions based upon a logical process of elimination.

However we may think to the contrary, I believe that most of us make decisions that are not logical, but emotional. Even the most outwardly logical person has deep-seated emotional reasons for their choices; they justify their decisions with data and logic, while denying the emotional basis of their decisions.

A friend in need is a friend indeed

Not admitting the power—or even the existence—of your emotional life is akin to standing in the middle of a busy highway; you are bound to be hit by the very thing that you deny. Why not admit to this powerful force, not as an enemy that needs to be controlled and conquered, but as a friend who is willing to work for your ultimate benefit, and help you create the life of your dreams?

Emotions can be measured in our brains in the kind of waves that are generated in reaction to our thoughts. Today's society emphasizes left-brain functions, which generate high-range beta waves in response to stress; these in turn have an effect on what we experience as our reality.

Les Fehmi and Jim Robbins in their book *The Open-Focus Brain* describe what happens to the brainwaves during a stressful situation: "Narrow focus (high-range beta-wave thinking) exacerbates fearful circumstances; and then when circumstances have changed and we are no longer in 'danger,' we tend to stay in narrow focus as a way of avoiding our residual feelings of fear and anxiety, accompanied by a middle-to high-beta range of frequencies to keep unpleasant feelings from surfacing."[2]

It is not that we need to control our emotions; rather we need to first understand how they work, what effect

2 Les Fehmi and Jim Robbins, *The Open-Focus Brain* (Boston: Trumpeter Books 2007. 19

they have on us, and then to know how to properly use them. Later we can learn how emotions help us manifest what we want. It took me a long time to realize that all beliefs have an emotional charge that makes them seem more real. Beliefs "stick" to us with the magnetic force of their emotional content, like burrs that cling to one's pants after a walk in the forest; beliefs established in childhood can last for an entire lifetime.

Strong beliefs built upon diametrically opposed emotions are mutually exclusive. In other words, you cannot have two diametrically opposed feelings—love and fear—at the same time. For example, someone who is jealous doesn't feel love; instead what they are feeling is a fear of abandonment, a basic human neurosis.

A negative emotion can know no thoughts connected with love, because negativity is born from fear. Conversely, the state of love admits no thoughts or feelings based upon the emotion of fear. In other words, love knows no fear and no limits; we can affirm this easily through numerous stories of incredible feats of courage inspired by love. One such famous account comes to mind: a child was trapped under an automobile; his mother lifted the car up so that he could be dragged out. Was her sudden phenomenal strength and unreasonable confidence due to simple adrenaline? Or was it due to a love that knew no limits?

Fear feels constrictive; love is expansive. Fear is shortsighted; love lives in wide horizons. Fear is like

looking into a closed box, while love feels like you are standing in a room with facing mirrors that reflect into infinity; you see yourself reflected in everything, and everything reflected in yourself.

> *"You shall always find what you created in your mind, for instance, a benevolent God or an evil Devil. Between them are countless facets. Therefore, concentrate on the depth of your consciousness and on what you consider to be positive and good."—Hans Bender*

Fear attaches itself readily through emotion to material objects, people, and possessions. Love possesses nothing and no one, and exists in a state of timelessness.

If we spend our time obsessing about our beauty, success, and material possessions, we are in our left-brains, and can know only time and loss. Thus, we are living in fear, which expresses itself most of the time as a dull anxiety, that occasionally flares into full-blown terror. If, on the other hand we love, the energy of our love beams out into the universe and never ends, eternal and timeless.

The art of love

The practice of art is akin in many ways to the art of making love. To practice art, one has to be in a state of

relaxation and openness, the same mood that characterizes the state of love.

Fear, especially fear of failure, makes creative thought nearly impossible because it shuts down the creative centers of the brain. Most fears are based upon beliefs. Beliefs engage the ego and trap it when the emotion of fear, in all its many permutations, is attached to a belief.

"The lines of communication between the conscious and unconscious zones of the human psyche have all been cut, and we have split in two"—Joseph Campbell

It is this emotional charge on the thought that makes our fear-based beliefs real to us. The ego can get to the point where it identifies so much with thoughts and beliefs that it actually thinks that it will die if it cannot hold those beliefs.

This form of the ego—which I call the *fear-ego*—if left unchecked, can be the most tyrannical monster there is: I have personally witnessed the lengths that my *fear-ego* was willing to go to maintain its ascendancy and not change. After a particularly intense period in my life when I was forced to change, I wrote wryly in my journal, "my ego thought that it was going to die, and it wanted to take me with it."

Hungry ghosts demanding attention

People are often afraid of ghosts, but what if we thought of them as just leftover emotional discharges? Perhaps belief systems are more like the *hungry ghosts* of ancient Eastern literature: they demand that we recognize and identify with them. It is through their hungry addictions that the ghosts of our imagination materialize before us—*as* us.

The *hungry ghosts* of our beliefs stick to us through our identification with them; without the "stickiness" that our emotions provide they cannot exist at all. Our emotions are what give our beliefs life. Like ghosts, beliefs are not real, and have only the power that you grant them.

Beliefs use enormous emotional resources, which could better be used for other things. If, through inner discipline, you succeed in losing the emotional charge connected with the belief, it disintegrates into meaningless words and loses its power over you. To me, the state of detachment that many philosophers endorse can be gained by losing the emotional charge of one's beliefs. Thus mental freedom may be won by disengaging the emotional charge from your thoughts.

Can I have a witness?

Have you ever seen a toddler fall on her bottom? It takes a while for her to sort her feelings; it is almost as if she has to think for a moment what she should be

111

feeling—"Maybe I should cry; then someone will come and comfort me." A child practices her emotions—instinctively she knows that they are useful tools. Emotions are an act at first; it is only later that we come to believe in them.

I recently saw a hilarious video of a small child throwing a tantrum. When the parent shooting the film moved out of view from the boy, he stopped crying, and followed his parent to the next room. There, when he knew he was being observed, he once again flopped on his stomach, kicking and screaming in rage.

As his father moved to the next room, the tears and screams stopped like a faucet turned off; he followed his father into the next doorway, only to start his tantrum all over again when he knew he was being observed.

We are all acting out

There is an interesting premise in the book, *The Celestine Prophecy*, by James Redfield: it states that most people are trying to get energy in the form of attention from other people in any human interaction. This is achieved through a manipulation technique: the Poor Me whines, the Interrogator criticizes, the Intimidator dominates, the Aloof is distant and cold.

These modalities are developed in childhood as a survival technique: to a baby, getting attention equals survival. The strongest and most insistent baby bird is the one that gets all the food. Redfield's theory is that

since most adults are not really mature, they cannot help but act out their insecurities. They continue to try to get energy or attention from everyone around them.

> *"Art is the elimination of the unnecessary."*—
> *Pablo Picasso*

This is the reason many people love drama: it is an effort to call attention to themselves. In order to survive physically, mentally, and emotionally, children have to get attention from the adults around them. Bad behavior from a child means that the child is hungry for love.

Children have to find a way to replace the energy that they feel is lost in interactions with the insecure people around them. Attention equals love to a child. Adults have learned to mask this call for love and attention in more sophisticated and cloaked manipulation techniques.

We carry these coping techniques developed in childhood into adulthood: we all have them to a greater or lesser degree. Listen to any argument or disagreement and you will hear one or more of these four roles—the Whiny Poor Me, the Critical Interrogator, the Dominating Intimidator, the Cold Aloof.

Don Miguel Ruiz says, "Attention to the ego consumes the greatest amount of energy. When your internal reference point is the ego, when you seek power

and control over other people or seek approval from others, you spend energy in a wasteful way."[3]

When the energy normally used for upholding our self-importance is released, it can be rechanneled and used to create anything that you want. Don Miguel Ruiz states, "When your internal reference point is your spirit, when you are immune to criticism and unafraid of any challenge, you can harness the power of love, and use energy creatively for the experience of affluence and evolution."[4]

We have practiced our emotional acts so much that we have come to believe that our drama is real. The coping techniques we developed as children to get the attention necessary to survive—flag down your mother, get her attention or she may not remember to feed you—translates into an adult identity. We are so crazy that if we don't have trouble in our lives, we sometimes feel constrained to create imaginary distress just to fit in with the rest of society.

People create a drama or story about their needs to make them feel more real to themselves and to others. Personal drama certainly feeds the monster of self-importance. This habit is deeply ingrained in most of us: after all, it was effective at making you noticed when you were a baby. Psychiatrist Mark Epstein on the subject of the ego:

3 Don Miguel Ruiz, *The Four Agreements* (San Rafael, Amber-Allen Publishing, 1997), 56
4 Don Miguel Ruiz, *The Four Agreements* (San Rafael, Amber-Allen Publishing, 1997), 56

...(there are)...two poles of the false self: namely, the grandiose self developed in compliance with the parents' demands and in constant need of admiration, and the empty self, alone and impoverished, alienated and insecure, aware only of the love that was never given.

The grandiose self, while fragile and dependent on the admiration of others, believes itself to be omnipotent or self-sufficient and so retreats into aloofness or remoteness, or, when threatened, clings to an idealized other from which it hopes to retrieve its power.

The empty self clings in desperation to that which it feels can assuage its hollowness or retreats to a barren void in which it is unapproachable and which reinforces the belief in its own unworthiness. Neither feels entirely satisfactory, but to the extent that we are governed by the demands of the false self, we can envision no alternative.[5]

The egotistical ego

I think that it would be safe to say that in Dr.. Epstein's view—and in the view of many philosophers—any personality based upon the feelings of self-importance is false. The illusion of the self—and the myopic state it produces—clouds the vision. The basis of such blind megalomania is fear: relentless, droning fear. The

5 Mark Epstein, M.D., *Thoughts Without a Thinker* (Cambridge: Basic Books, 1995), 64

result is a closed mind and heart. It is virtually impossible to have a new experience or innovative thought in such a self-absorbed, closed state.

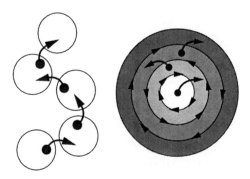

It is the nature of human beings to live within the reality of their own thoughts and within that of the society in which they live. The diagrams above illustrate two different ways of visualizing the dynamic potential of creative thinking.

Each circle in both of the diagrams represents a closed system of thought. Imagine that you are trapped within the first circle on the left picture or in the inner circle on the right picture.

The diagram on the right has arrows on the edge of each circle that demonstrate the circling pattern of our repetitive thoughts. What forms the circle of reality that the individual perceives is a pattern of thought, a system of belief. Each reality system is mutually exclusive of all others.

What keeps a circle strong and closed is the power of emotion and belief. Emotion provides the "glue" that holds the circle of thought together, and keeps the thinker inside. Each circle or "truth system" seems all-inclusive; it is closed. In fact, normally a person who lives inside one of those circles of thought cannot escape the circle or "reality" of his thoughts into another circle.

Only creative thought, represented by the jumping arrows, can escape the gravity of a closed system. The concentric rings of the diagram on the right resembles the path of electrons around a nucleus. Carrying this rough metaphor further, an insight or inspiration causes an "electron" of free thought to escape the habit of its path, and it enters another loop or thought-system represented here by another circle.

The inspiration is "captured" by the new system, and the individual that generated the creative thought accepts a new reality. Once an artist has developed creative freedom, these leaps over self-imposed mental limitations become an everyday occurrence, but they never get less exciting, because new mental landscapes are so alluring.

The importance of self-importance

Don Juan in Carlos Castaneda's book *Journey to Ixtlan* claimed that at the bottom of every negative thought and emotional reaction is a colossal sense of self-importance. It was easy for me to see this in angry people,

but it was some years before I realized that victims are massively self-important as well. Angry people feel victimized and act out in "self-defense."

The Dalai Lama says, "Suffering is optional." [6] When I first heard this statement, it seemed to be outrageous and insensitive. Aren't some people helpless victims of others, of disease, or of fate? How is it fair to say that oppressed people have a choice?

Then I realized that while people may be in unavoidable, sometimes excruciating pain, some *choose* not to *suffer* from it—they *choose* not to see themselves as victims. This view puts them in a different reality. It doesn't mean that the pain goes away, that they ignore it, or that they become desensitized, only that they are aware that they have a choice in how they are going to translate their experiences.

Many artists have used their pain as a subject in their work. This can have an effect that I like to call *sublimation* —a term that I have discovered is also used in psychology:

> *Sublimation is the refocusing of psychic energy (which Sigmund Freud believed was limited) away from negative outlets to more positive outlets. These drives that cannot find an outlet are rechanneled.*

6 This does not mean that one should not have compassion for victims. However, a person who identifies with being a victim cannot leave behind the event that provoked the story, and victimizes themselves through their interpretation of the event.

For example, a student who has a major upcoming test, rather than spending time and energy worrying about it, might rechannel that time and energy into studying; and an angry person who is accustomed to wasting time and energy on lashing out at others, might instead rechannel those outlets towards expressions of art, music or poetry.[7]

Soul-alchemy

In science, sublimation means that a substance has gone from one state to another state, without going through an intermediary state—such as going from a solid to a gaseous state, without becoming a liquid. An artist who releases and expresses his emotions through his work may find that his process carries him smoothly from one state—for example, depression or longing— into a state of happiness and attainment.

The artist's emotional expression can be transformative on not just the artist, but on the viewer as well. Artwork of this kind is a window on the human experience, revealing things that may otherwise remain in the dark for an entire lifetime.

What we don't want to know about ourselves exists in what is often referred to as the *shadow self*. Everything about yourself that you don't like, you repress; every-

7 *Sublimation* (psychology). (2007, August 29). In Wikipedia, The Free Encyclopedia. Retrieved 02:46, September 27, 2007, from http://en.wikipedia.org/w/index.php?title=Sublimation_%28psychology%29&oldid=154323060

thing that you despise becomes the shadow personality. Energy cannot disappear, it can only move or transform. Your negative emotional thoughts have to go somewhere, and these feelings form the shadow self.

I have come to believe that the shadow self develops as a coping technique in childhood to deal with trauma that cannot be processed properly by the child-mind. Understanding that this terrifying shadow self was developed by a child is essential to reintegrating it into oneself.

The shadow self is a just a child in arrested development: it is not to be feared, but it must be allowed to speak. Art is one of the safer ways to allow it to come forward to express itself.

I think that nothing need be thrown away, despised, repressed, or devalued, in fact it is impossible to do so; one way or another the truth and the shadow self will out. Like the genie that couldn't be stuffed back inside the bottle, we just can't ignore it. If we do, we will find ourselves in disease: mental, emotional, or physical disease.

Both health and disease are the result of our innermost thoughts and emotional reaction to those thoughts. The child inside us wants to be loved, knows he deserves to be loved and accepted for who he is, as he is—unconditionally. The only way to do that is to let him speak. The best way I know to do this is through art.

We all have stuff that we throw into the enormous bin of the subconscious. Unearthing these uncomfortable, sometimes downright disturbing mental/emotional issues, is an act of incredible courage, and a kind of psychic cleansing.

> *"The shadow is a moral problem that challenges the whole ego-personality, for no one can become conscious of the of the shadow without considerable moral effort."*—*Carl Jung*

Art is one of the ways to go deep into this danger zone safely. Personally, I write poetry when I am emotional, and I find that once the poem is out, I feel good. It has the same effect on me as listening to blues music does: the theme is sad, the content is emotional, but the process of creating the poem delivers me into a state of happiness. Art like this can be sublime in that it touches the human soul.

We may not be able to choose what happens to us, but we can choose how we react to the event. A person in an unconscious reactive mode has only two possible reactions to a perceived negative event: anger or self-pity. Actually both are self-pity, and are based upon a sense of self-importance.

Self-pity results from a feeling of disconnection or a sense of being unloved. The spiritual affliction that seems to affect most human beings is a fundamental

fear of abandonment. Child psychologist D.W. Winnicott refers to this basic human insecurity starting in early childhood as the *fear of being infinitely dropped*.

Fortunately, the feeling of separation is only a relatively modern mental illusion, one created by the same mind that created time, history, distance and separation. The Hindus call this illusionary world Maya:

> *"Maya in Hinduism is a term describing many things. Maya is the phenomenal world of separate objects and people, which creates for some the illusion that it is the only reality. For the mystics this manifestation is real, but it is a fleeting reality; it is a mistake, although a natural one, to believe that maya represents a fundamental reality. Each person, each physical object, from the perspective of eternity is like a brief, disturbed drop of water from an unbounded ocean. The goal of enlightenment is to understand this —more precisely, to experience this: to see intuitively that the distinction between the self and the universe is a false dichotomy. The distinction between consciousness and physical matter, between mind and body...is the result of an unenlightened perspective."* [8]

8 Wikipedia contributors, *Maya* (illusion), Wikipedia, The Free Encyclopedia, http://en.wikipedia.org/w/index.php?title=Maya_%28illusio n%29&oldid=159028877 (accessed September 20, 2007).

In contrast to the *Maya* of left-brain thinking, the creative mind lives in a different reality of limitless possibility and timelessness. So in order to leave the fear-based limited thoughts that constitute the *Maya* of human existence, all one has to do is to learn to use our natural creative capacities. Through the practice of art, we can teach ourselves how to clear the mental/emotional fog of fear-based thinking.

For me, any creative activity restores my sense of connection with everything around me. I often feel that the force of creativity works through me. I am not a little ego creating something out of nothing; I am simply putting myself into a stream that is always continually flowing. When I work, I am offering to flow with that stream, or rather, I allow it to flow through me. It has its own direction, its own reason. The clearer my emotions are, the less I attach my ego to the results, the easier the creative process becomes.

I can verify from personal experience and from the experiences of my creative colleagues that the natural high of the creative process is hard to equal. It has the feeling of rightness to it, a feeling of connection, of making bridges, of being in love.

If you don't use it, you lose it

What is more human than emotion? Emotions can be addictive in nature, especially the stronger, more dramatic ones.

Emotions release chemical reactions in the body in response to our thoughts. The hypothalamus in the brain produces certain chemicals called peptides that match the emotional states that we experience on a daily basis. There are chemical peptides for every emotion. Science has now found that this works on a cellular level: the cell becomes addicted to those emotional chemicals that it habitually receives.

> *"When you create you get an endorphin buzz. Creation is better than drugs."* —Robin Williams

In a classic vicious cycle, the cells receptors need increasingly large doses of the chemicals that they are used to receiving. When the cell reproduces a daughter cell, it now has receptors for those chemicals; it does not include receptors for other emotional chemicals that the parent cell did not receive, such as those engendered by love. In other words, the daughter cell's aptitude and ability to receive any other emotions have atrophied.

Dr. Joseph Dispenza states, "We bring to ourselves situations that will fulfill the biochemical cravings of the cells of our body by creating situations that meet our chemical needs. An addict will always need a little bit more in order to get a rush or high of what they are looking for chemically...if you can't control your emotional state, you must be addicted to it." [9]

9 *What The Bleep Do We Know*, Directed by Mark Vicente. 20th Century Fox, 2005

Thus the individual has developed an addiction to the emotions that he has practiced, and a lessened ability to experience other emotions. In order to reverse this effect one has to consistently practice feeling ever more positive emotions.

Viewing the world through colored glasses

We are emotional beings; I used to wonder what is the real use for emotions. Why do we have them? At this point I was introduced to the concept of *skillful* and *unskillful* emotions. Daniel P. Liston states: "In Buddhist psychology emotions are classified as 'skillful' or 'unskillful'...these skillful and unskillful emotions are opposite because they are part of a single dialectic. Anger is a perversion of love, transformed in the crucible of frustration. Anxiety is restricted excitement. Envy is a contracted form of empathy, since both spring from the capacity to know another's experience." [10]

I translate the concept a bit differently—I like to say that the unskillful use of emotions is revealed anytime that the emotions work against you, against your better self. Anytime your emotions are reactionary and unconscious, they are unskillful. Whenever you consciously choose your emotions, they are skillful.

So, if you blew up at the guy going slowly through the intersection, your emotion of anger was unskillful, because it did you no good, and did not improve your

10 Daniel P. Liston *Teaching Learning, and Loving: Reclaiming Passion in Educational Practice*, (London: Routledge Falmer, 2003), 119

circumstances. If you go further and slam your car into the guy or into someone else, your outburst actually hurt you and someone else. A skillful emotion is one that is deliberately chosen, and works for you, such as employing passion to realize your dreams.

10

Imagine or remember the feeling of joy. How did it physically feel? Where was it located in your body? Now, do this same thing with fear, excitement, and every emotion you can imagine.

Emotions are your natural guide

Emotions are a great compass for either finding your path, or evaluating whether you are squarely on it. Whenever you find yourself in an unskillful emotion, you will feel uncomfortable and powerless. You can tell you are in the dark, off the path, because you are feeling unhappy. Whenever you find yourself in a skillful emotion, you feel happy, invigorated, and you look forward to the unknown with excitement. You can use this good feeling to ascertain that you are on the right path, doing the right thing.

Everyone has a different way of experiencing emotions in their bodies. Next time you feel a strong

negative or positive emotion note how it felt and where you felt it. It will have an actual location in your physical body. For instance, when I feel anxiety, my throat constricts and my stomach contracts. When I feel exhilarated or happy I feel an open, expansive feeling in my chest.

Use your feelings like a compass to your emotional life: skillful emotions and a feeling of happiness are your true north, indicating a positive direction or choice. The unskillful emotions point south on your compass towards a poor, undesirable choice. The feeling in your body associated with each emotion is a reliable indicator of your preference in the moment, and, more generally, your best life direction.

Emotions are the gateway to intuition

As a human being gifted with more than her share of emotions, I used to wonder what purpose they serve. Finally the answer came to me. In the middle of a particularly intense period in my life, the phrase "Emotions are the gateway to intuition" came spontaneously to me. It was only in the following year that the full meaning of the phrase delivered from my subconscious became clear. This information forms the basis of this chapter.

Scientific research bears evidence that the right-brain "knows" things that the left-brain cannot conceive. This knowledge which is the spontaneous synthesis of

bits and pieces of tiny bits of information—sometimes so tiny as to be subliminal—is intuition.

> *"Music is the shorthand of emotion."*
> —*Leo Tolstoy*

Changing the channel on the story of your life

What is the overriding story of your life—the dominant emotional theme that you keep coming back to again and again? As long as you are not conscious of what is happening in your emotional self and do not make an effort to change, you will remain in the same story, imprisoned inside the same feeling for life.

Some people carry a story or feeling that makes their life a veritable nightmare.. Other people experience a dull ache or a feeling that there must be more to life. Some of my coaching clients cannot even remember the last time they felt joy. Why do people get trapped in an unhappy story? It is because they don't realize that they have within them the most amazing power at their disposal—creative action.

When I was a small child my parents encouraged my siblings and I in the study of natural history. We collected a motley assortment of small animals from the woods around our home, and assigned them temporary homes in boxes and terrariums on our enclosed porch.

One day I wanted to see the golden eyes of a toad in a round glass bowl we had on the table. He was faced

the other way, toward the wall, so I turned the bowl. As I rotated the bowl to the right, the little creature hopped to the left.

If I turned the bowl faster, he hopped just as fast in the opposite direction. I laughed as I realized what he was doing—he was trying to keep his view the same. The toad's reality was based upon his perspective, so if his view changed, so did his reality: therefore, it was imperative that he do what he could to sustain his point of view, even if it meant he had to physically move.

How many times have we found ourselves in the same position of trying to keep our view the same? We don't want to change our perspective; we cling to it, and will persist against the odds and the elements.

We can be so fearful of change that we'd prefer a familiar pain to anything else. Usually we have to have a crisis of faith before we can change, and then we are brought to the change kicking and screaming, without realizing its potential benefits. We would rather be right than be happy.

We don't realize how easy it is to change; it can be done on a dime as long as we are prepared for change. One of the best ways to do this is to lose the emotional attachment to one's own story. People are addicted to their emotions and to their story. Most of us identify strongly with our personal history, because it gives us a sense of security in a chaotic world.

A chain is only as strong as the weakest link

Reactionary thinking follows a predictable pattern: A thought engenders an emotion which then results in a chain reaction. This chain reaction—thought to emotion to reaction—happens at an unconscious level in most people.

> *"That something happened to you is of no importance to anyone, not even to you. The important thing about you is what you choose to make happen—your values and choices. That which happened by accident—what family you were born into, in what country, and where you went to school—is totally unimportant."*
> *—Ayn Rand*

The first step in breaking the chains that bind us is to be aware of our emotional reaction. Every time you have a reaction, step back, notice it, and mark what outside event triggered it. Awareness is always the first step towards change.

Wait a moment between each stage of your reaction; see yourself choosing your thoughts, your emotions, and finally, your reaction. When you can see what is happening with detachment, you have discharged the emotional component from the thought, and have broken the chain of your emotional reaction.

Mark Epstein knows the secret of dispassionate observation: "Sometimes we feel that the only solution is to act out every emotion that we get in touch with. We feel as if we must express it to whomever it is directed or that we are somehow cheating ourselves. The idea of simply knowing the feeling does not occur to us." [11]

Q: When do we get to drop the rock?
A: When we stop gripping it so hard.

Drop the rock

As a personal trainer, I learned how to read my client's emotional and mental history through their physical bodies: I could tell a lot from a person's physical condition and posture—their overriding emotional landscape, and their personal story. Many seemed to be carrying an invisible burden on their shoulders.

One day, as I was contemplating the concept of dropping personal history, I found a piece of graffiti stenciled on the sidewalk: it said, "Drop the Rock." Like a message dropped from the sky just for me, it was a metaphor for how our personal history—our story and the emotions connected to it—is like a heavy rock that we are carrying on our shoulders.

There is a saying in the south, "He is as serious as a heart attack." Most of us are fighting the gravity of our thoughts, represented in the size of that invisible rock

11 Mark Epstein *Thoughts Without A Thinker: Psychotherapy from a Buddhist Perspective*, (New York: Basic Books, 2004), 119

we are carrying. Often we do not want to release our attachment to our personal burden and drop the rock, but when it finally happens, the effect is incredible.

When heavy concern for the self is gone, your thoughts and emotions are free to guide you towards your natural preferences, and towards the fulfillment of your dreams. Suddenly the world becomes crystal clear and perfect: it feels as if you have just flipped your view outward instead of inward.

The box in which you were living suddenly turns inside out, and you are an observer in a beautiful, immensely interesting world. It is as if you have walked into the real world, after having lived your entire life inside a flat black and white photo. Colors are more intense, space seems somehow more 3-D than before; everything is truly perfect; there is a wonderful variety, taste, color, texture, and tone to everything.

> *"In order to change conditions outside ourselves, whether they concern the environment or relations with others, we must first change within ourselves. Inner peace is the key. In that state of mind you can face difficulties with calm and reason, while keeping your inner happiness."*
> —the Dalai Lama

Because you are no longer comparing what you see to any ideal of perfection or to what you think it

should be, beauty exists in every nook and cranny, even in what you may have formerly considered ugly. This is the essence of the artistic experience.

11

OBSERVE OBJECTIVELY

Try this simple exercise right now: choose to look at any object in your surroundings. Stare at it with a soft gaze, empty your thoughts and see it as if you have never seen it before. Notice everything about the object, see it without reference to its function, history, or aesthetics. The longer you are absorbed in really seeing your subject the larger and more interesting it will become.

Achieving 20/20 vision

Practice detached observation by softly gazing at an object in your surroundings. Note every detail. When your subject has finally lost its name, close your eyes and let yourself see it with your mind's eye. Observe it again with your eyes closed. Once you can turn your object around in your mind, and you can see it from every angle, you have mastered not only the art of pure observation, but the art of visualization as well.

Echoing the words of Leonardo da Vinci, I used to tell my students at Parsons The New School of Design that they will know that they are artists when they can find the stains on the floor of the New York subway interesting without reference to what made the stain.

"Seeing is forgetting the name of the thing that one sees."—Paul Valéry

The talent of seeing what is going on inside another becomes easier to do once the fog of your own thoughts and emotions no longer cloud your view. Understanding others, their motivations, habits, and blind spots becomes easy, because we are not trying to mold them into anything else. The capacity for pure observation is achieved in tandem with emotional clarity. Through the practice of his art, any artist can learn to become a clear, detached observer.

This state usually doesn't last, however, the shortness of its duration doesn't make it any less valid or valuable. It's just that most of us will be tempted back into the flat-photo-reality by the force of our habits and our social distractions; the slippery nature of the ego demands it.

The self, the ego, and the artist

As an artist you may choose from a smorgasbord of themes to explore: ideas, relationships, emotional issues,

social issues, politics, and so on. Any one of these could last one session or your whole life. In my creative life, I have explored many themes; at one point, I, like many artists, found myself exploring the theme of identity.

Some people believe that the aim of Eastern philosophical thinking is the dissolution of the ego. This always seemed odd to me: as the only beings on this earth that have evolved an ego, there must be some reason for its existence.

You may disagree with me, but, as an artist, I can find many interesting things about the ego. What's more, I need my ego in order to survive in this world as an artist. An artist's job is to explore whatever is at hand in his environment. The artist's own ego, like the proverbial elephant in the living room, is material that is hard to ignore.

Exploring identity in art can illuminate how the self is formed, and how it can be molded consciously. Mark Epstein states:

> "...(the self is) just an idea that we dream up while young...Since it is just a fixed idea— and one made up by a child, no less—it cannot possibly be an accurate representation of an ever-changing human living from moment to moment. As such, while preserving this self-concept, we are in a constant battle to defend something that is indefensible. The issue here, of course, is that

defending the indefensible is no way to be happy.
Therefore, we should stop deceiving ourselves
and really examine this issue."

Dr. Epstein concludes that the solution is to: "simply drop this ridiculous concept of 'who we are', and to start being what we are! Who we are is not a fixed image, but an ongoing story. It is not only new in this very moment, but will be new again, in the next moment." [12]

It is not the self that we are dropping, since this self never did exist; it is an illusion, a fiction, a story created in our youth—a delusion that we have forgotten is only a belief.

That initial thought that we had as a child has been made real by thinking it over and over again; its stickiness is due to our emotional attachment to the story we created from our beliefs. It is our emotions that make these beliefs into an identity that clings to us like skintight clothing. The good thing is that, like clothing, we have the power to take off that particular "identity" and put something else on.

The real magic of emotions

If life's purpose is creative expression, and we are here to experience our innermost desires; then how can we get there from here? Remember the equations stated earlier?

12 Mark Epstein, M.D., *Thoughts Without a Thinker* (Cambridge: Basic Books, 1995), 11

THOUGHT + PRACTICE = BELIEF
BELIEF + PRACTICE = REALITY

So, if you think something a lot it eventually becomes a belief. If the belief is practiced enough it becomes reality. Normally this process is rather slow. That is a good thing when it comes to negative thoughts and beliefs. Imagine what would happen if we could manifest any thought instantly—we would be creating all kinds of nightmares from our random thoughts.

We have to practice a thought a lot for it to manifest. This is a safety valve to protect us from our own creative power. Until we understand the power of our thoughts, and have the discipline to focus on what we want, the natural distance between our inspirational thought and its eventual manifestation has a reason to exist. Our own disbelief about the creative power of our thoughts both protects and disables us.

However, some of our beliefs come true faster than others—the secret is in how we are using our emotions. A thought can come alive, it can become real much more quickly when there are strong emotions present.

There is a great metaphor for this process in the movie *Frankenstein*. The mad scientist, Dr.. Frankenstein, wanted to animate the artificial man he had constructed from the bodies of dead criminals. He used a lightning bolt from a thunderstorm to give his creation life.

In the same fashion, strong emotion is the bolt of energy that gives life to both creative inspiration and unconscious beliefs:

THOUGHT + STRONG EMOTION = ACCELERATED REALITY

Love and passion work just as well as fear and anxiety. They just tend to have different results. Most of us don't want the reality that the emotions of fear and anxiety help to create, but find ourselves helplessly creating unwanted things all the time because we are at the mercy of our powerful emotions.

Since we are not choosing our emotions, we cannot choose what we unconsciously create. All kinds of monsters teem at the edges of our imagination waiting for a bolt of emotional energy to set them into motion.

All emotion is just "*e*-nergy in *motion*," neither bad nor good, but powerful nonetheless. Sometimes that energy gets trapped and swirls around inside us, making us feel anxious and fearful.

The following formula makes a good mantra to repeat to yourself if you find yourself in fear or in the middle of an anxiety attack:

EMOTION IS JUST *E*-NERGY IN *MOTION*

All we need to know is how to properly use our emotions to reset our reality to one of our choosing.

Like the alchemists of old, we can create gold from base materials. All we need is a catalyst. That catalyst is the *skillful* use of emotions. Clearing away unskillful emotions (the ones you were programmed with) and replacing them with skillful (or chosen) emotions is the key.

> *"Creativity can solve almost any problem. The creative act, the defeat of habit by originality, overcomes everything."*—George Lois

Remember the Reticular Activating System from Chapter Four? Science says that the R.A.S. lets in only data that meets at least one of the following criteria: the data is important to your survival, it has novelty value, *or it has a high emotional content.* Here is scientific proof of how we can change our reality with the power of our emotions. In this case, instead of being controlled by our emotions, we can choose which ones to generate, in this case, finding and feeling passion.

Creative inspiration comes from the nonverbal, nonlinear right-brain. Why? Because the left-brain cannot perceive without beliefs. Only the right-brain can know intuitively the right course of action, because it is not cluttered with words, social agreements, arguments and limiting beliefs.

To determine the right action to take, however, we need one final element: *clarity*. Once the false or

outmoded beliefs are gone, clarity has a chance to enhance vision. Clear vision allows intuition to become a real tool in your life. Intuition is an unfailing source of knowledge and direction.

It may be that you don't need to take an action, but that doesn't matter, because action or non-action is a conscious choice led by intuition, and guided by vision. In other words, if you have no rigid beliefs, you have the clarity to use intuition to see the right path or course of action, even if that path is the course of inaction.

Let's reduce this equation down to pocket size so that you can take it home with you:

VISION + PASSION = MANIFESTATION

You use your passion to activate your vision into creative manifestation. For short, I like to play with the word impassioned, changing it to being *in-passion*.

The thrill of the unknown

Notice that belief is no longer a part of this equation at all. When beliefs are no longer being upheld, a space has been created for something new to emerge. You are holding open a "magic circle" of pure potential where anything might occur. Beliefs take enormous energy to uphold, energy that can be more productively used for creating whatever you want.

*"Since my subjects have always been my sensa-
tions, my states of mind and the profound
reactions that life has been producing in me, I
have frequently objectified all this in figures of
myself, which were the most sincere and real thing
that I could do in order to express what I felt
inside and outside of myself."*—Frida Kahlo

Thoughts are not in the equation either, not the
kind of thinking done with the left-brain. In fact, the
whole process of creative inspiration comes from the
right-brain. Silent knowledge, that gut feeling that
has nothing to do with data, information or rational
thinking, is stronger than any mental confabulation.

Eventually, the rational left-brain must conclude
that it can no longer hold to its version of reality if the
whole person is to benefit. For that, it needs to dump
beliefs and habits regularly, which is very challenging
for it, because it loves certainty and structures.

The left-brain functions in the same way as a
computer; it is expert at the kind of logical, linear
thinking that is similar to computer programming. A
computer works in a world of the concrete and literal. It
has zero tolerance for any kind of abstraction, poetical
allusions, or ambiguity—diametrically opposed to the
kind of holistic understanding and fuzzy logic that is
necessary for creative thinking. In a computer program

if any one little detail is missing, like a semicolon, letter or dash, it can crash the whole machine.

If I miss a letter or period in one of my sentences, you might think that I need lessons in grammar, but you would still get my point, because you can understand my gist from the whole sentence, or from the paragraph. A computer program cannot infer the sense of something unless it is perfect in syntax. Book titles and newspaper headlines make easy examples of how the position of an element changes its expected meaning.

If I switch a noun for a noun, the title of a book like *Women Who Run With the Wolves* still makes sense, but becomes suddenly funny (an artistic trick). It becomes *Wolves Who Run With the Women.* If instead, I mix up the syntax, the title becomes nonsense: *With Run the Women Wolves Who.*

Of course an artist could take the idea of mixing up syntax and create an entire piece or even create a new art form from this simple exercise. I once heard a local poet recite poetry that he cobbled the stanzas together from the subject lines of spam email that he received.

The syntax of the spam headlines was already garbled in order to get through the spam filters; the art was in how he recognized spam as prime raw material for his poetry. The effect was at once innovative and hilarious.

Mathematician and author Lewis Carroll was a master of syntax, and logic.

Examine this stanza of his famous nonsense poem, *Jabberwocky*:

> 'Twas brillig, and the slithy toves
> Did gyre and gimble in the wabe:
> All mimsy were the borogoves,
> And the mome raths outgrabe.

What's fun about this poem is the masterful way the author handled syntax. An artist can use the unifying effect of syntax to organize his piece, but Lewis Carroll uses the expectations of the reader—set up through the structure of syntax—to identify the function, but not the meaning of each of his new nonsense words.

Jabberwocky works only because of the syntax of the piece: the poem has no meaning beyond its structure. In other words, the relative *position* or *context* of each word defines its role.

Look again at the poem. *Borogoves* becomes a noun because it is behind the article *the*, while *mome* becomes an adjective for the following nonsense noun *raths*. *Outgrabe* becomes the verb for whatever those pesky *raths* do. The syntax of language is just the kind of structure that the left-brain expects to find in every situation. An artist learns to use any structure as a kind of language, a tool for communication and expression.

12

Here is a fun way to use syntax. Take any written text that you see: the titles of the books on your bookshelf, or a line in a magazine article; switch the words around. Sometimes the sentence works, other times it makes no sense at all, and at other times the new order has a different meaning altogether.

Dance steps on the floor

The kind of creativity that the left-brain can produce is much more limited than the right-brain; it is limited to the boundaries of logic, reason, and expected structure. The steps are very well defined: step four follows step three, which follows step two, and so on.

To the left-brain you have to have a beginning, middle, and end. No drawing outside the lines or leaping over fences here.

The logical, linear left-brain lacks the magic, the uncertainty, and the wonder of pure creativity. But working in tandem with the inspiration and synthesis of the right-brain, it provides the stability, structure, form, and the critical view necessary for creative work. The left-brain can aid the right-brain in setting up a good environment for creative acts of wondrous import.

The compass is included

Whether expressing what needs to be said through art, or harnessing passion for achieving your life's dreams, emotions are incredible tools for the creative individual. What are other uses for emotions? They are indicators of what we naturally prefer.

Once our emotions are of the skillful variety, our preferences will naturally indicate our path in life. How will you know your way? Use your *happiness meter*. Does the contemplation of an idea or course of action make you feel depressed, lethargic, or bored? Or does it make you feel happy, exhilarated, and perhaps a little scared? If that is so, then it is right for you.

Emotions anchor memories—have you ever noticed that the memories with the most reality are the ones associated with strong emotion? Once you have cleared yourself from unskillful emotions, you can use your emotions for all kinds of things.

If you anchor any thought or desire with emotion, you can make it have more reality or concreteness. You can use emotions to help you remember events, reconstruct your reality or build your future.

Don't use negative emotions in this process or the opposite of what you want will happen: you will succeed in pushing what you desire away from you. Because your thoughts are focused on the lack of what you want—or, if it is something that you don't want, your feelings of lack or aversion will attract it to you.

Magnetic attraction

Are you attracted to someone with a negative mood or to someone with a positive mood? While you may be temporarily attracted to a negative person so that you can commiserate, in the long run, a positive person makes you feel better about yourself and about the world.

We create things in life with the help of others; that can't happen if you are repelling other people with a negative outlook on life. If you tell everyone how horribly others treat you, and about how things just never go your way, you are setting yourself up to be alone in your failure.

On the other hand, if you radiate confidence and a positive mood, others who can help you will come around. Your mood makes it easy and fun for them to help you.

Appreciation adds value

So far we have talked a lot about what most people call *negative emotion*—emotions with the root of fear at their base. I want to introduce the idea it is possible to remain relatively neutral to your own emotions, rather than being victim to them. The point is not to replace negative emotions with more positive ones, but to be able to consciously choose everything in your life, including the emotions.

All emotions are good; some may simply feel better to you. Think about an incident where you felt a negative emotion. Feel it as a physical sensation in your body. Does it feel constrictive? Now, focus on an incident where you felt a positive emotion. What feeling do you have in your physical body—isn't it one of expansion and relaxation?

We have said that the opposite of fear is love. I prefer to replace the "L" word with the word *appreciation*. This word is especially useful because it has a dual meaning. In the stock market, if you invest a positive dollar amount in an asset, it has the possibility of appreciating.

In the realm of emotional reality, when you appreciate something or someone sincerely, you are opening yourself up in a marvelous way; turning your attention outward, and donating a bit of energy back to the stock of the universe, in which, karmically speaking, we are all stockholders.

Appreciation throws baby fish into the karmic pool to stock it with new life. Whenever you show sincere appreciation, your original investment of attention appreciates. Cultivating something you like with the power of your attention causes it to produce more of the same.

"Even after many years of psychoanalysis, after teaching psychology, working as a therapist, after taking drugs for many years, being in

India, being a yogi, having a guru, meditating for 18 or 19 years now—as far as I can see I haven't gotten rid of one neurosis. Not one. The only thing that has changed is that while before these neuroses were huge monsters that possessed me, now they're like little shmoos that I invite over for tea.—Ram Dass

George Ohsawa, the father of Macrobiotics, expressed this natural law eloquently when he said, "One grain: ten thousand grains." In other words, for every grain of seed that is planted, the yield from each mature plant is exponential.

When you use emotionally positive energy in anything, there is a high probability that the energy you have invested will come back to you magnified:

$$APPRECIATION \times SINCERITY = ORIGINAL \ ENERGY^2$$

This equation is extremely powerful in dealing with other people, however, the thought behind your words has to be absolutely sincere or it will backfire on you. People have an amazing ability to detect insincere flattery, because it is a common manipulation technique.

The difference lies, as always, in the intent behind your words. If you tell someone something to get energy from them, then you are manipulating them for gain;

if instead you are expressing yourself with true feeling, then you are practicing the magic of appreciation.

> *"...and in the end, the love you take is equal to the love you make."*—The Beatles

The return on your investment may come from an entirely unexpected source. Do not expect or demand it from the place you made the original investment. The art of giving freely to others without expectation or strings is a sophisticated technique of appreciating whatever you have, according to karmic law.[13]

Some people may have trouble expressing appreciation for others because they are shy; if that is the case with you, just practice appreciating what is your environment or in your life. Once you become expert in the art of appreciation, you will find it much easier to deal with other people.

Expedition to the South Pole

We have all heard about the power of positive thinking. However, what was always lacking for me was the emotional and practical component. I find it hard to believe affirmations because they seem like an intellectual graft on top of a different emotional reality.

13 "Karma literally means 'deed' or 'act' and more broadly names the universal principle of cause and effect, action and reaction that governs all life. Karma is not fate, for man acts with free will creating his own destiny. According to the Vedas, if we sow goodness, we will reap goodness; if we sow evil, we will reap evil."—"Karma," Wikipedia. http://en.wikipedia.org/w/index.php?title=Karma&oldid=210488993 (accessed May 12, 2008).

What's more, I didn't realize that the best way to get beyond the barrier of negative thought patterns is to act first, not to try to believe first and then act. Sometimes you just have to *act as if* and let the belief follow.

Actors know this; just acting as if you are another person can generate the reality without needing to believe it first. An actor doesn't believe that he *is* the character he is playing, if he did, he would be crazy; instead, he acts *as if* he believed. Acting as if something is true is one way to get it to be true. But the real power resides in knowing that whatever it is, it is only as real as you choose to believe.

The real thing

So what do natural emotions look like? To know the answer, we have only to look at small children. A child clearly feels emotions, without judgment or resistance.

Emotion flows freely in children. You have seen it: from one moment to the next a baby can go from anger or sadness, to happiness and contentment and vise versa. Emotions should be just as fluid for adults.

"That's OK for a baby, but how can I do that as an adult," you say. "And why should I?" To be able to deliberately shift one's mood is a clear sign of emotional freedom. The technique hinges on self-importance, and the degree to which one clings to it. Remember my secret formula for eternal youth?

STRENGTH + FLEXIBILITY + {THE ABILITY TO BE SILLY} = YOUTH

Once it clear that your emotions are only as real as you believe, it becomes easier to lighten up. The practice of art can give us the courage to face our deepest fears with grace and productive results.

> *"I don't have personal history anymore…I dropped it one day when I felt it was no longer necessary."*—Don Juan, Journey to Ixtlan

Emotional freedom

The first step to emotional freedom is to get to a place where you no longer resist your emotions. For this to take place several things have to happen first:

Refuse to tell yourself that you are a victim or victor. Don't buy into the story on either side of the drama. Most people can't wait to win against someone else. This perpetuates a habit that wastes personal energy, and in the end no one actually communicates or actually wins.

Don't take anything personally. What happens to you is not due to any vendetta against you by any person or by God or the universe. It just is, view it impersonally and objectively as possible. This doesn't mean that you

don't step out of the way or defend yourself; you just know that someone else's emotions don't have anything to do with you. The boxer who gets mad usually loses the fight because he took the battle personally and not dispassionately.

> *"The hardest thing to see is what is in front of your eyes."*—Goethe

Dump any personal history that supports a victim story. Tell yourself anything else; choose another story. After all everything you are feeling is just a story you are telling yourself. If you want a different emotional reality, just switch the tape you are running in your head.

Don't forgive; understand. Forgiveness is another one of those overused terms that now means something quite different than it meant originally. Or it may be that we now need to create a new term that describes how we should deal with others. The word forgiveness carries old overtones of victimization and superiority.

It implies that you have the power to forgive someone else for what they did to you; acknowledging that they could do something to you makes you their victim. As a forgiver, you switch from the inferior victim into a superior forgiver, but that doesn't change the energy of the exchange. It hasn't become right simply because the participants have switched roles.

It is far better to understand that most people are acting out of unconsciousness. They are reacting to the pain they feel from self-victimization, intolerance and self-judgment. Even an abuser feels like a victim. You hear it in their testimony, "She made me hit her."

It takes a rare individual to realize the similarities that join us all. The *fear-ego* nearly always wears a disguise, but it is easy to see once one understands its need for superiority. Most people are not operating on a very conscious level. When you practice detached observation and understanding, you can exit all the drama, and achieve the clarity and freedom of detachment.

> *"Discussion is an exchange of knowledge; argument is an exchange of ignorance."*
> —*Robert Quillen*

See others as impersonal, unconscious forces of nature. No one can do anything to you, if you refuse to be a victim. No one is a victim. You can only be a victim of the story you tell yourself. Don't assume that anyone has any consciousness about his or her actions.

Flow and redirect "negative" energy. Take a lesson from the practice of martial arts: martial artists learn to flow around violent force and redirect energy. In not opposing others, in understanding them, by not allowing yourself to be a victim, in allowing the natural

flow of your emotions, you are redirecting your vital energy to a better, more constructive use: your health and well being.

To sum up, a person with healthy emotions:

1. Feels without resistance, indulging, or residue.
2. Is not attached to their personal history.
3. Is clear of feelings of victimization or anger.
4. Can see others with detached understanding.
5. Uses their emotions as a guide.
6. Allows for more than one point of view.
7. Shows sincere appreciation for others.

I love to play with anagrams. Like the rhyme in poetry, they are a mnemonic device. This one actually describes the creative developmental process that is the core of this book. This anagram can help you overcome personal limitations and lessen your reactivity if you are in an emotional meltdown or find yourself lost in mental confusion:

CONNECT WITH YOUR INNER CHILD
OBSERVE DISPASSIONATELY
PLAY INCESSANTLY
EXPRESS YOURSELF

Hearing the little voice of intuition

How do you know when it is the voice of intuition or the voice of fear? Sometimes it is both: this is when your intuition is telling you that you need to pay attention to something in your environment. Most of the time, however, the voice of fear is a conditioned reflex responding to outdated thoughts and not what you need to hear. Your intuition can be an amazing source of instant information: it can tell you everything from inconsequential details to something as important as the direction your life should take.

Emotions are habits; a habit is simply something that we have done so much that it has become an ingrained unconscious activity. A silly, but effective exercise I used to do to connect with my little voice of intuition concerned my daily morning routine.

In tracking my behavior, I noticed that I spent way too long in the morning deciding what to wear. I realized a strange thing; that, after trying on several outfits, I usually ended up wearing what I first had thought of that day. This first choice was usually ideal for the weather and for the occasion. Why was I wasting so much time with my wardrobe?

So I decided to immediately put on the first outfit I thought of that morning, without question or second-guessing. I saved myself a lot of time and energy this way. I now know that this little voice that speaks first is my intuition and that it is usually right. It is initially

difficult to remember to listen to it, because it is usually drowned out by all the other voices in our heads.

In what ways do you waste time and energy? As they say in the old adage: "let me count the ways..." Track your habits, both mental and emotional. See how they manifest physically. Don't waste time in self-criticism, just figure out the tracks of your habit; follow its path, as you might follow an animal in the forest. Find out what path it follows and how your habit feeds off your precious energy.

It is said that all habits are composed of elements and that those elements need to be in a certain order for the habit to persist. So, let's say that you find yourself eating candy at 10 a.m. everyday. You can track the things that lead up to this habit: in this case, perhaps you are hungry at 10 a.m. because you don't have breakfast, you don't have breakfast because you don't have time in the morning, you don't have time in the morning because you wake up late, you wake up late because you are tired from staying up late the night before. If you break any one of these elements, or take it out of its position, you can break the habit.

We all know this intuitively, but as explained in Chapter Two, we are often stuck in a dysfunctional relationship between our adult persona and our child self—between what would be good for us and our childish nature.

Actually it is not that we get pleasure from indulging in bad habits—most of the time they aren't really enjoyable—it is that we derive a sense of comfort and security from their familiarity. I have heard it said that people who smoke are looking for something to do with their hands. Smoking could be regarded—once the nicotine addiction is addressed—as a nervous habit that could be replaced by a less self-destructive habit that similarly occupies the hands.

Act *as if*

As a child I was painfully shy. When I was 17 years old, I entered college a year early in the summer semester. My parents couldn't change the family vacation plans by then, so they let me vacation by myself for two weeks. It was the first time I was on my own. One day I had the astounding idea that since no one knew me there, I could be whoever I wanted to be.

I decided in that instant to *act as if* I were outgoing and gregarious. It was a marvelous and unexpected idea that seemed to come out of nowhere. True creative inspiration is always like that—when the divine muse talks, listen, and immediately act without thinking.

I believe that what followed was the first truly creative act of my life. In an instant, I transformed myself into a new person: I spoke up for what seemed to be the first time in my life and talked to a group of adults at the pool; something formerly inconceivable to

157

the person I had been only seconds before. I'll never forget how those people accepted the new me instantly and without question.

From that day, I became an extrovert; no one today suspects that I was originally an introvert. Everyone believes that I am the person I decided to be that day long ago. I have even come to believe it myself.

Exercises:

Become someone else for an hour
Remember the movie *Rainman?* Dustin Hoffman studied autistic people to prepare himself for the part: the mannerisms he noted became his costume.

Hoffman was autistic in every part of his being because he started with a compassionate understanding of the mental and emotional basis of the character. His character became real to us through the quirks and body language that expressed the inner feelings of the autistic person that he had studied.

Try another personality on as if it is a costume: the further from your own, the better. Choose a venue where no one knows you: a bar, a bookstore, or a cafe. You may want to dress the part to help yourself effect the transformation.

You may choose to be someone who is self-assured if you are shy, or shy if you are confident. If you are soft-spoken, try being loud, if you are usually loud, be quiet and unassuming.

A brainstorm on the desert
Write a plot for a novel or for a screenplay. Allow your imagination free rein for a day, and just let yourself consider anything and everything—the wilder, the better.

For example: what if there was a desert planet on which almost all the water had disappeared?

What might ensue? How might water be conserved and stored when the atmosphere is so hot and dry? How might the lack of water affect social organizations and individuals on that planet?[14] How would your single *what if* affect the emotional landscape of every character in your novel or screenplay?

An artist is in touch with her emotions, not in control of them. She wants to know what they are, because they are inspiration for her work; she knows that her real work is the development of herself.

The artist is here on earth as a human to feel emotions, as an artist her job is to explore and express

14 This sounds like the premise for a science fiction story, and in fact, it is the premise for the classic science fiction epic series *Dune* by Frank Herbert.

those feelings, as a conscious creative she learns how to use emotions for her own evolution. Emotions are not just how we feel and understand the world, they are an indispensable element in the creative process.

"Sex energy is the creative energy of all geniuses. There never has been, and never will be a great leader, builder or artist lacking in the driving force of sex."—Napoleon Hill

6

THE SECRET OF SEX

It wouldn't be right to talk about creativity without referring to the greatest generative power that we all have—our sexual energy. The previous chapters outline the processes for freeing yourself, and for setting your creative energy in motion. Now, the secret of sex is revealed—in order to create something, one can utilize the same force that is used for creating new life: sexual energy.

Actually, this is not a secret for some. Sex and creative energy have been linked for a long time. One system—the *chakra* system, referred to in the ancient literature of the Vedas, which originated in India more than four thousand years ago, identified seven major energetic centers of the human body.

Chakra is a Sanskrit term that means "wheel" or "circle," referring to the way that energy was seen to swirl in these areas on the human body. The system identifies one of those centers as the sexual *and* creative chakra. The second chakra is the Swadhisthana or the sacral chakra, located in the groin and is related to base emotion, sexuality—and to creativity.

The reason why many spiritual traditions and other esoteric disciplines eschew sexual activity is to enable the disciples to have more energy to apply to other activities, such as contemplation, esoteric or academic studies, and athletic training.

It is said that all energy is sexual. It is a fact that all action requires energy, and the action that requires the greatest amount of energy is creativity.

The reason that creative activity requires a great amount of energy has to do with the principle of inertia. If an object is already moving, the force required to move it is less. Conversely, if an object is at rest, moving it requires greater force. Creating something new is analogous to trying to move an object from a standstill or even reversing its direction.

Sexual magic

The sexual drive is arguably one of the most powerful forces in nature. It has the power to bring together two disparate elements and through a veritable alchemy, produce a third element; this power is so amazing that

it defies the laws of mathematics. Adding two opposite elements together creates a third element:

$$1+1=3$$

How magical is that? All of nature shows us that the sexual creative force is one of the most powerful forces in this universe, and it is ours to command! How we utilize our power is up to us. Many people are drawn to having children. The task of raising children is an endeavor of immense proportions that requires a lot of sustained energy over a great numbers of years.

Creating a new project, new business, or work of art requires energy as well. Depending on the extent and duration of the project, it could consume a small or great amount of energy—sometimes as much as creating a child. How can we marshal, utilize, sustain and nourish that energy?

Attraction and creation

Sexual energy has two main functions: attraction, and manifestation (creation). The first draws in energy and the other produces something.

When utilizing the first function of sexual energy— the power of attraction—one begins to attract things and people to oneself. As an artist, I work with what comes to me: materials, concepts, environmental conditions, etc.

Like a spinning vortex, you don't have to even move to get what you need, you simply draw it to you. We all do this with the power of our thoughts and our emotions, as shown in former chapters; the difference is that a creative individual does it consciously.

> *"Creativity arises out of the tension between spontaneity and limitations, the latter (like the river banks) forcing the spontaneity into the various forms which are essential to the work of art or poem."*—Rollo May

Desire, Eros and sexual energy

Attraction is activated by desire. Most of us have experienced both attraction and desire; like the polar ends of a magnet, it can be said that a kind of energy flows from the attractor to the desirer and back again.

We are energetic beings in an ocean of energy. Any time there is a strong feeling there is energy, and all energy can be used however we want. Without wants or desires, we would never move anywhere, we would not feel a need to do anything—we would be like a rudderless boat floating in a bland sea of indifference.

On the other hand, the experience of curiosity and desire causes us to want to explore our surroundings and look for that the missing, opposite half. I like to think of attraction and desire as a kind of propulsion device: it is through the tension or friction of our desires that we

move. The light of the attraction we feel allows us to see the path or direction we must take.

It is the tension between opposites that generates something new. In sex, the sexual act culminates optimally in a child, so the tension between having and not having, desire and attainment is the force that creates something new. Someone who has everything they want is simply in bliss. Nothing is needed, nothing is desired; therefore nothing new is needed to fill the void, to assuage the ache of desire.

Many artists talk about the need for tension in art. What is this tension that they speak of but the tension of desire? Desire is the feeling that results from the condition of not having; it is the inspiration of many great works of art. Desire stimulates the extraordinary expenditure of energy that creativity requires. Without the tension of desire, nothing new would be created.

"You have to systematically create confusion, it sets creativity free. Everything that is contradictory creates life."—Salvador Dali

Desire exists in our archetypes and legends. The loss of the beloved and the subsequent quest is the subject of many a story and myth. The quest for the Holy Grail could easily fall into this category. The exquisite poems of Rumi express the desire for the beloved, the longing for reunion, the unending search for what was lost. The

reason these poems still speak to us after over 700 years is because the human experience of desire and quest speaks to the generative creative force inside all of us.

The object of one's desire becomes more attainable once desire is aligned with one's thoughts, and activated with emotions. The energy of desire draws us toward the object of attraction. When we attain that object, it transforms into something else, because in attainment or consummation of the desire, the object of desire is no longer attractive.

We move onto the next desire, the next attraction. This might be disappointing until one realizes the real energetic function of desire and attraction is *movement*, or to bring it full circle—the real function of desire is *manifestation*, the secondary attribute of sexual power.

When the Buddhists say that the cause of all suffering is desire, this is what they mean: the unconscious cycle of desire and consummation that is life for most of us. Until we learn how to use desire skillfully, we can never be happy for long, because there is always another thing to avoid or desire.

Like a horse that perennially circles on the track because of the carrot in front of its nose, we are not happy in the cycle of desire and consummation, because once attained, the object of desire simply changes into something farther off. The real trick is to learn how to use the generative force of desire without becoming stuck in the cycle of desire and consummation.

The movement or tension of desire is what Joseph Campbell refers to when he says that proper art is static and improper art is kinetic; he means that art should not produce more of this endless cycle of hopeless desire and consummation, but should instead cause what he calls "aesthetic arrest," the suspension of time. This is what I like to call "stopping the mind." Art like this has nothing to do with the intellect or with thought, but rather presents the viewer with a singular experience.

"People say that what we're seeking is a meaning for life...I think that what we're seeking is an experience of being alive, so that we actually feel the rapture of being alive."
—Joseph Campbell

Ultimately the transcendent orgasmic arrest, the heart-stopping sublime experience is what we really want from life. We want it from sex; but we can have it in art, and in the practice of art as well, as often as we want.

There is a marvelous sculpture by Bernini, an artist of the Renaissance, that shows this moment most exquisitely: an angel, resembling the god Eros or Cupid, has pierced the breast of St. Teresa with an arrow as she writhes in an agony of pleasure. This could just as easily represent the aesthetic arrest of the transcendental art experience. In the same way an orgasm is often called

"the little death," with good reason—it is a moment when time stops, when the ego momentarily dies; a moment when the self dissolves and merges with another, and when normalcy is suspended from thought.

Joseph Campbell on the subject of desire in art, "Art that moves you to desire is pornography...It has to do with a relationship to the object that's that of social, physical or otherwise action. You are not held in aesthetic arrest."[1]

Desire is pornography when it identifies the source of one's passion with an object outside oneself. So one may say that such an artist is a hunter of his subject. The goal of the profane hunter is pursuit, conquest, possession, and ultimately, the destruction of the object of his desire.

Step in the current and allow it to sweep you away

Beginning artists often experience frustration when they step back and evaluate their work; it is never what was desired, it is never good enough. This is because the conception and execution of the piece was based upon an objectified desire. They are the "profane hunters" who wanted to capture that expression or reproduce that still life exactly; they are upset because they were not able to do what they set out to do.

One of the differences between an amateur and a master artist is that an amateur hasn't yet learned the

1 Joseph Campbell, *The Way of Art*

secret of harnessing desire into passion. Like a hunter who kills the very thing he admires, some artists want to master, possess, or capture the subject of their art. They make the mistake of thinking that the object of desire is outside them, and far away. The problem is one of time, space and distance, an illusion that the left-brain never seems to overcome.

> *"A great artist...must be shaken by the naked truths that will not be comforted. This divine discontent, this disequilibrium, this state of inner tension is the source of artistic energy."*—Goethe

The confusion that has arisen regarding the use of desire has to do with confusing the *object* of desire with the *energy* of desire. The trick to using desire in any creative act is to retain the feeling (or tension) of desire, while losing the idea of attainment, possession or consummation; ultimately to the point of not even of having an object of desire. It is this energy of desire that creates, not the desire or the inspiration itself.

Successful artists consciously use, channel, and groom their passion as the force of creation that it is. Artists can master desire to the extent that it no longer has an object. When this happens, desire turns into non-objectified passion. One no longer desires to possess the object of desire, or to attain any goal at all; the only thing that exists in the world is the passion one

is experiencing. Mastering the art of passion is to simply tune into the feeling of non-objectified desire over and over again.

Grooming a sense of passion for one's art or for one's subject is one of the ways that artists build and sustain energy for creative work. The everyday world is often distracting if not overwhelming; it can be difficult to find time and energy to create, so an artist draws upon her passion in order to help her work; her work becomes a source of passion. In this way she recycles her creative energy and recharges herself.

> *"I want to touch people with my art, I want them to say 'he feels deeply, he feels tenderly."*—*Vincent Van Gogh*

Make love with your art

Many artists experience making art as an act similar to the act of making love. Like a lover who finds a universe of sensation in the texture, scent, sight and sound of his beloved, an artist feels desire as he contemplates his subject, he feels passion and sensuality as he explores into his materials; he is fully present inside his passion as he works.

Art can be created in an instant or can be drawn out over months or years: I have executed a painting or drawing in a few seconds, while other pieces were achieved over several months. Some series of paintings

following a singular theme have taken as long as ten years to complete.

Sustaining passion, excitement, desire, or even interest in a project can be challenging. Half the battle is in choosing the right project. But the trick of the artist is the ability to both nurture his passion and sustain the pleasure of creation.

Knowing how to generate interest, sometimes to the point of obsession, and to be able to consistently produce work without any thought of reward is the mark of an artist. Art is not about producing anything at all, it is about sustaining attention, interest, and passion.

Exercises:

Sweet nothings whispered in your ear
Focus your attention on a simple musical phrase to create a sensual auditory experience. Vary the elements of your medium—rhythm, repetition, variation, etc.—to express the emotions of passion, desire and longing.

Fill your senses
Create a non-objective image in which the subject is the sensual nature of the medium itself. Paint can express sensuality without representing anything.

The play is the thing
Create a script where the main characters are passion, desire and longing.

Sweet nothings whispered in your ear
Write a story that follows a desire like a traveler from its point of inception to its final destination. Make the desire itself into a character that develops and grows during the course of its journey.

The capacity to lose oneself in passion and in the pleasure of creation means that, for the moment at least, the ego has been dropped. Where self-consciousness ends creative freedom begins.

"Why do you try to understand art? Do you try to understand the song of a bird?"—Pablo Picasso

7

THE CONSCIOUS CREATIVE

The world is a feeling

I have a friend who is a composer, musician, inventor, philosopher and engineer. I have had many discussions with him on what it means to be a creative person in today's society. There are some differences between a musician and a visual artist: I work without considering an audience, while he composes with an audience in mind. The visual artist usually works alone, while a musicians works with others.

In stark contrast to the solitary, almost meditative nature of painting, music is more communal in nature. As a composer, Peter needs to take into account—almost into partnership—the people listening to his music and the musicians who are to play his pieces. In contrast, as a visual artist I usually work alone, and do not think about

an audience at all. However, despite the differences in our choice of media, we are both artists in our hearts and souls. The reason I like to talk to Peter so much is that we both know how it feels to be creative.

> *"Creativity represents a miraculous coming together of the uninhibited energy of the child with its apparent opposite and enemy, the sense of order imposed on the disciplined adult intelligence."—Norman Podhoretz*

In one of our conversations, I made a statement that I knew he would take in the vein it was intended: namely, that because I am an artist first, and a painter second, I could successfully create a piece using sound as my medium. I could make pieces that are entirely sound art. I am not a musician but I could be successful in a medium that is completely new to me.

One of the ways I could do this is to use my understanding of the artistic process and skills within a new medium. For example, let's take the idea that I elucidated in Chapter One: "The creative process proceeds from the simple to the complex."

I could start with a single note as a theme and repeat, elaborate, and embellish it until I have a whole piece. The reason this works is because are so many parallels in the creative process that it is extremely easy to transfer general principles from one medium to another.

Unreasonable self-confidence

The essence of the creative state can be distilled down to a feeling. When I was just a child, I felt like an artist, therefore I was an artist, before I really was one. It was this certainty that drove my search for the knowledge and skills that would help confirm my inner conviction. Knowing without proof, against all obstacles or disbelief is a way to access future knowledge, and is a basis for faith in oneself.

Obviously, operating out of sheer feeling is not really possible in other, more exacting fields, like medicine or engineering. It would be absurd and dangerous to claim that one was a physician or engineer just because one felt like one. However, the mood or feeling of creativity is essential to being an artist.

An artist nurtures the creative mood, even when others tell him that his work is not valid, even when his work is overlooked or unappreciated. To practice this feeling over and over again, the artist practices his art. The artwork produced is merely the carrier for the feeling, not the other way around.

Once a person has mastered the feeling of being an artist in any medium, it is possible to work in any other medium. I started out as a painter, but over the years I have explored video, sound, interactive art, humor, dance, graphic design, and poetry. All I have to do is transport the mood of the artist over to the medium I have chosen. In fact, it is often an advantage to not

know the medium that well, the work that results can be surprisingly fresh that way.

Have a happy accident

Whatever medium you have been using, treat yourself to a change, and switch to something new: pick up a new tool or better yet, conscript a non-artistic tool into service. Set yourself up for what I like to call "the happy accident," allowing the element of randomness to play in your work. In the process of working with an unfamiliar medium or tool, you can discover an entirely new art form.

13

HAPPY ACCIDENT

Set up yourself up for a *happy accident.* Be inventive according to your chosen medium. Allow paint to run freely over the surface of your painting. Go out into the street and record whatever sounds you encounter to use in your music. Sample random text from printed material; create a poem from the words you have found.

Changing mediums is one well-tested way for an artist to regain freshness and interest. Picasso moved easily from painting to ceramic design, to sculpture—

as he did so his work became increasingly naive and childlike. A state of innocence is one of the most essential elements of all forms of creativity, from fine art to math, to marketing, to science.

Many other artists try to return to explore the naive state that existed before they learned their craft so well: artists such as Pablo Picasso, Henri Matisse, Francis Bacon, John Cage, and David Hockney. Author Ernest Hemmingway was known for his deliberate simplicity and direct writing style.

> *Creativity is allowing yourself to make mistakes. Art is knowing which ones to keep."*
> —Scott Adams

Francis Bacon remained a painter all his life. He refused to make any preliminary drawings, because he wanted to elicit the spontaneity of nearly accidental paint splatters. He was the master of the happy accident. He used whatever he found around him, including the dust from the floor of his studio.

In contrast, an elderly Henri Matisse decided to take up the art of collage when his fingers became too arthritic for him to hold a paintbrush. Some people see his childlike collages as his best work.

After mastering a hyper-real style in his youth, David Hockney moved towards an increasingly naive style of representation. His style evolves and morphs constantly.

As he does so, his work becomes simultaneously more ingenuous and more innovative.

Composer John Cage explored the nature of pure chance, "In the late forties I found out by experiment... that silence is not acoustic. It is a change of the mind, a turning around. I devoted my music to it. My work became an exploration of non-intention. To carry it out faithfully I have developed a complicated composing means using I Ching chance operations, making my responsibility that of asking questions instead of making choices."

> *"One looks, looks long, and the world comes in."*
> —*Joseph Campbell*

Be the radio, and the transmitter

There are two basic modes in the sophisticated play of an artist: input and output. In the first mode of input, an artist "gathers" feelings, thoughts, and impressions from her environment. *Gathering* may last for minutes or for years. It is often not related to a specific goal, the artist is simply collecting material for a nonspecific purpose. Since everything is useful to the artist, nothing is discarded.

In the alternating mode of output, the artist synthesizes new things from the data she has collected. In order to gain the mood of receptivity, she has to practice openness: any fear or judgment spoils the

act of creativity. Long before the actual creative act, there has to be a period of receptivity. In order to be receptive, one cannot be afraid of criticism. Without allowing receptivity and openness, the artist cannot escape her own judgment—let alone that of society at large—long enough to receive any information from her environment.

Once you have dropped fear of attack, judgment, and disbelief, you are able to receive all kinds of things. In becoming open you are defenseless to success.

The mood of deliberate innocence allows the creative person a chance to see everything fresh and new, as if with the eyes of a child. It allows him to question everything, and observe clearly.

A general mood of receptivity and openness fosters simple, unprejudiced observation. This mood allows the artist to gather information and stimuli freely from his environment. To be creative, it is first essential to relax the mind, and clear it from prejudice; from what the mind says is important.

The art of doing nothing

You have to fill the well of the creative mind before you can draw from it. Gathering or "floating" as I like to call it, is like eating a great meal. It is difficult process to describe—probably because it is more like a state of meditation, or a mood, rather than an actual process.

14

Take a mini vacation today to a place where you can just wander around freely; pick a location where you will see unique and random interesting things: a toy store, a thrift shop, the seashore, a junkyard, or a museum. Put yourself in a place where you can just softly observe what floats before you. Be like a wide-eyed baby in his high-chair; just take in the show that is going on before your eyes. Draw no conclusions, make no judgements, and force no events. Collect souvenirs in the form of photographs, or small items, to use in your art.

When you gather and float, you don't have to worry about filtering the experiences and impressions: that will happen naturally. Your right-brain not only records everything you experience, but it filters every impression. Like the gravel that surrounds a well, it filters your experiences, letting in only what is useful to you. Trust that it will automatically return whatever you need to you at the exact moment when you need it.

The return of a filtered experience is often marked by the epiphany of an inspiration. That inspiration may come minutes or many years later, but it always comes.

In just such a way my experience with the toad in Chapter Five that happened when I was only eight years old became an epiphany about change and point of view only years later in my coaching practice. Now, my childhood encounter with the toad that did not want to change his mind or his point of view has become art. As art the image of the golden-eyed, intransigent toad is transmitted to everyone who reads this book.

That is the magic of our incredible, flexible, creative minds. To the right-brain there is no passage of time, so anything stored there is evergreen, always available, and fresh.

Like an amazing, endless cornucopia of riches, our brains have the capacity to intelligently gather the most succulent morsels of impressions, and feed our creative selves with the most delicious of meals: experiences that suddenly have meaning, or, to put it another way, enhanced consciousness, or, to put it even more succinctly, art.

Make floating a regular practice: make time to do nothing. Allow yourself time to let go of daily concerns, pick a place to wander with no goal, purpose or destination in mind.

Notice whatever comes to you when you are in this state of soft observation. You don't need to record your random impressions; know that what you need will naturally come to you when you work.

The art of simplicity

A great example of a creative thinker who mastered the art of simplicity is Einstein. One of my favorite stories is of how he couldn't remember where his home was located: he often got lost going home. He was focused on other questions that no one else thought to probe, such as relativity. It takes a genius (or a fool) to ask a simple question. At the very least, it takes someone who will openly risk looking foolish.

15

PRACTICE NAIVETE

Look around you. See an object and ask a deliberately simple question. Imagine that you are a four-year old child who inquires from a seemingly endless list: "Why is the sky blue? Why is the earth round? Why do cats meow and dogs bark? Why can't water flow uphill? Why do we have hair on the top of our heads; why don't we have hair on the bottoms of our feet? Why don't we get smaller rather than bigger as we grow older?" Simple questions can spark both sublime and ridiculous ideas.

Trivia, such as Einstein's phone number or address, simply wasn't important to him so he disregarded it.

One of his colleagues asked for his telephone number one day. Einstein reached for a telephone directory and looked it up. His friend was astonished that he didn't remember his own number. Einstein riposted, "Why should I memorize something I can so easily get from a book?" In fact, Einstein claimed never to memorize anything that could be looked up in less than two minutes.

> *"Creativity is a type of learning process where the teacher and pupil are located in the same individual."—Arthur Koestler*

A mind like Einstein's spends very little time focusing on detail and data. His type of mind spends the greater part of its time in right-brain thinking where conclusions are drawn from seemingly unrelated data. This is called *synthesis*, and it is an important phase of the creative process.

In order to have an open mind, it cannot be filled to the brim with nonessential trivia that clouds the creative process. This is what Einstein meant when he quipped, "Imagination is more important than knowledge."

The proper mood of creativity would require that Einstein not prejudge any thoughts; that he remain open enough to question the obvious. The things that others took for granted inspired him: light, energy, and gravity. This is real creativity and true genius.

A creative mind questions everything

Creative thinkers have a long history of being willing to look foolish, and often go against common sense or against the wisdom of the times. When the Catholic Church issued an injunction against the dissection of the human body, artists such as Leonardo da Vinci risked his life and his career to achieve the intricate sketches he gifted to posterity.

An artist develops and nourishes a deliberate naiveté. He learns how to ask the deceptively simple question that everyone else overlooks. This is the signature of a creative mind.

Here is another anecdote about Einstein: One evening he was asked by his hostess at a social gathering to explain his theory of relativity. Einstein rose to his feet and told a story. He said one day he was walking with his blind friend and had a sudden desire for a glass of milk.

> *"Drink" replied the blind friend, "I know what that is. But what do you mean by milk?"*
>
> *"Why, milk is a white liquid," said Einstein.*
>
> *"Now liquid, I know what that is, but what is white?"*
>
> *"Oh, white is the color of a swan's feathers."*
>
> *"Feathers, now I know what they are, but what is a swan?"*
>
> *"A swan is a bird with a crooked neck."*

"Neck, I know what that is, but what do you mean by crooked?"

Einstein said he lost his patience at this juncture in the conversation. He seized his blind friend's arm and pulled it straight. "There, now your arm is straight," he said. Then he bent the arm at the elbow. "Now it is crooked."

"Ah," said the blind friend. "Now I know what milk is."

And Einstein, having made his point to the guests at the tea function, sat down.

Learning how to see

The practice of art teaches and enlightens the practitioner. As the artist expresses emotions and investigates new ideas her work becomes an exploration of her mental, emotional, physical, and spiritual landscape in every possible direction. Once the self is opened, it is then just a matter of learning how to see the way an artist sees.

Simplification is a key directive for learning to see like an artist. When an artist draws a new subject, she reduces everything down to its simplest form.

But before the artist even starts, she makes some very important decisions about scale and choice of medium. The composition is decided upon—some artists use simplified sketches called thumbnails. In the

Renaissance the preliminary sketches for paintings were called *cartoons*.

A modern cartoon is the same thing: a simplified drawing. Simplification and reduction of complexity remains one of the most important tools of the conscious creative. Simplification is one of the things that is perceived as beautiful by the mind. Beyond its scientific meaning, the beauty of a mathematical equation such as $E=MC2$—lies in its utter simplicity.

16

SIMPLIFY AND REDUCE

Find a photograph in a magazine. Using tracing paper and a pencil, try to reduce the image down to its most basic shapes like squares, circles, and triangles. All these shapes can be found in everything we see. Observe how everything around you can be reduced to a simple form.

The human brain is made to recognize patterns, make categories and understand metaphors. Patterns are recognized as a structural element and are used to enhance communication.

Once something is established as a pattern or structure, it is ignored and becomes a background or matrix for something else. The thing that rests on top

of the background is recognized as the subject—the mind focuses on it and ignores the rest. In the case of language the matrix of the grammar provides the background or structure for the meaning of the words. One may say that the grammar is the vehicle that carries the meaning of the author, and transports the reader from one mental image to another.

A great creative exercise is to change focus and subject matter. In photography this is called depth of field; a picture in which only one thing is in focus—the other elements in the photo are unfocused and become, by default, the background for the new subject matter.

Almost any work of art, even the most non-objective abstract painting, has a foreground, middle ground, and background. In general, *ground* means the background and *figure* means subject. Elements below an horizon line are more likely to be perceived as figures, while objects above the horizon are perceived as ground.

The background is just as important as the subject, however. The background "grounds" or places the subject in a structural setting. The relationship of the figure to the background is the essence of visual art and design.

Music uses the same principles: one can draw a parallel between the background in visual art, and the orchestral setting which is the background for the subject in the musical performance—the violin soloist.

The structure of the key, and the background of the beat forms the structure for the melody.

Effective graphic design is built upon an invisible background that lends organization and structure to the composition of the page: this is called the "grid." People don't usually see the grid, but they are unconsciously aware of it.

When the grid doesn't exist, the design breaks down and is not as effective. The stabilizing nature of the grid is what enables clear communication.

> *"That little bit between each note—silences which give the form."*—Issac Stern

A savvy graphic designer can make his design more exciting by allowing the subject matter run outside and over the edges of the established grid. The "violation" of the invisible grid draws the eye, and makes the design more active and interesting. The reason is that the viewer now sees an object in the foreground over background elements. The subject overlaps and hides the background grid.

Ordinary magic

You remember the perceptual games and optical illusions they showed us in grade school? It seemed like magic when the silhouette image of a couple of vases abruptly flipped into a picture of two women facing

each other. This is a classic example of what is called a figure/ground relationship. It is a trick of the mind, not the image.

In this optical illusion the equal amount of emphasis given to both the black and white areas makes it difficult to determine which is more important. Usually, the background is larger and less distinct than the subject matter, which is smaller and in clearer focus.

17

SHIFT FOCUS

Try changing focus right now: look up from this book and into your room or out the window. Focus on an object in the foreground and then on one in the background. Practice switching your focus back and forth between objects a few times. See how everything else in the background and in the periphery of your vision becomes blurred and indistinct.

In the case of the flipping figure/ground image, the mind is confused; it cannot perceive both images at the same time, it has to flip between seeing the black faces as the figure and seeing them as the ground for the vases.

The tessellation designs of artist/mathematician M.C. Escher were inspired by the knowledge of this perceptual trick. Other artists deliberately use the negative space to create new conceptual pieces.

Most terms in one art form have their equivalent in other art forms. For instance, the negative space in art is the same as silence or the space between the beats in music. The negative space is just as important as the positive space or tones because its presence helps define the subject matter. The white space that surrounds each letter in this sentence is what defines the form of each word. In humor, it is the adept handling of the silence between the phrases—the timing—that makes a good comedic delivery.

Outer space was once the biggest negative space ever conceived by man, yet today, scientists suspect that outer space is not empty after all. Even the space between atoms and electrons is not empty.

For anyone to even conceive that *negative* may actually be *positive*, someone had to think upon negative space, or to put it another way, a creative thinker put his attention on the background behind the subject matter—he had to change his focus in order to think about what everyone else ignored.

Seeing what is not there

What most people—artists included—fail to remember is that pictures are optical illusions. The

illusion is not in the image, it is in our minds. The Renaissance in Italy introduced a new optical illusion to the world: Italian perspective. The artists who pioneered this technique discovered a new way of thinking, in fact, all subsequent Western thought and civilization was influenced by this new way of thinking.

18

NOTICE NEGATIVE SPACE

Take a break and spend some time noticing negative space in the world around you. It is everywhere in life, in art and in our minds. Look at a tree and see the space between the leaves; look at the space between the objects in the world around you.

In the art world prior to the Renaissance things that were more important were made larger, and less important objects or people were painted smaller. This is a very natural hierarchy: after all, to a primitive man, an animal that is nearby is more important than one that is far away.

When shown pictures of an elephant drawn in simple perspective, drawn from the side with two legs—the other legs partially visible behind the ones in the foreground—modern-day hunter-gatherers did not recognize it. Only when the elephant was represented

with all four legs splayed out in the image, did they know what it was. It registered as an elephant because all the essential elements that make up the concept *elephant* were there—the body, the head, the trunk, the tail, and the four legs.

It takes imagination and mental freedom to make less-than-literal interpretations. When perspective was invented in Italy during the Renaissance, it heralded a true revolution in Western thought.

The Renaissance artist showed not only a third dimension—depth—but a fourth as well. By representing three dimensional space the artists also represented time, which had not been represented in the iconic art of the previous era.

> *"The eye sees only what the mind is prepared to comprehend."*—Henri Bergson

However, it is only the first people who saw the pictures in Italian perspective who really had to use their imagination. Now, we have integrated the optical illusion of Italian perspective into our visual language, and forget that it is only one way to represent space. In the same vein, the representation of a landscape through a map was a huge leap in visual thinking, one that we have long forgot.

We communicate via symbols and pictures. An artist can draw or paint an image using as little perspective or

depth as possible, and the viewer will still see perspective and depth. It is virtually impossible now to make a piece of art merely two-dimensional, because of our modern tendency to interpret images as 2-D representations of a 3-D world.

The mind's eye

Human beings are bound by our nature to read something in something else. Our brains are designed to create and interpret symbols. Metaphors and new creative ideas may be drawn from many art principles: light and shadow, figure and ground, foreground and background can be thought of as metaphors for the known and the unknown, or as metaphors for the seen and the unseen.

Visual metaphors abound in art and design. Metaphors create bridges between concepts; the value of a metaphor is that it can make you see something in something else. The mind loves metaphors because a metaphor draws parallels between separate objects and makes connections between otherwise unrelated ideas.

Metaphors in art draw upon the basic human desire to see relationships and to make groupings. A metaphor helps make the new comprehensible by drawing parallels between that which we already understand and that which we are trying to understand. All art draws parallels of some kind; art speaks through a language of metaphor, icons, and relationships.

Metaphors are so ingrained in our civilization that most people don't even notice them anymore. Through the use of metaphor, new ideas ride on the foundation of older, more familiar ideas. The representation of a familiar desktop with virtual files and file folders made the computer interface easier to comprehend— the virtual computer interface was a huge leap in metaphoric thinking.

> *"The artist is not a person endowed with free will who seeks his own ends, but one who allows art to realize its purposes through him. As a human being he may have moods and a will and personal aims, but as an artist he is 'man' in a higher sense—he is 'collective man,' a vehicle and molder of the unconscious psychic life of mankind."*
> —Carl Jung, Psychology and Literature

Pearls of wisdom

A creative person is conscious of the symbols, systems and metaphors in modern culture because these are his tools for his art. Metaphors are used in art to hide meanings when the underlying concepts are difficult or the viewer needs to be led to unfamiliar conclusions. It is ironic that concealing a concept can make a message even more powerful. Our minds are intrigued and challenged by hidden meanings and puzzles.

Dreams often allow us to understand what is happening in our subconscious through the use of metaphorical imagery. The subconscious uses symbolic images to protect the dreamer from things that may be too painful to face. It hides trauma within metaphor in the same way that the oyster will build a pearl around an irritating grain of sand.

One could say that a metaphor is an early form of an archetype; or to use a metaphor: a metaphor is the child form of an archetype, and an archetype is the ancestor of the metaphor. An archetype is a cultural symbol or a symbol with a long history. Metaphors and archetypes are a way to tap into not only one's own subconscious, but into the collective consciousness of all mankind.

Artists know that dreams and metaphor are rich treasure waiting under the sea of our collective consciousness. This resource is available for anyone to tap at any time.

All in the family

The mind loves relationships; it loves to make groupings and families from the things it sees. A good designer knows this and uses it.

Things that belong together can be grouped together in several different ways: by proximity, by emphasis, by color, by treatment and by their relationship to other objects in the design. In graphic design and visual art grouping items together enhances comprehension and

communication. Families of objects make the perceptual habit of skimming possible. Instead of getting stuck at reading each individual item on a page, the viewer can take a shortcut by seeing the family of related items, instead of each individual object. The use of grouping is not limited to graphic design; it is used in every art form.

Groups and families are everywhere: a choir is a group of singers, a phrase is a group of words, a chorus is a group of dancers, and a theatrical company is a group of actors. The use of families allows us to speed comprehension by providing logical structure.

19

FORM GROUPS & FAMILIES

Take a bunch of unrelated items and see how many groups you can make from them. There are many ways you can group things: by color, function, size, etc. Then take one of the groups—say a group of red items—and scatter them over a monochromatic background. See how the family of red remain related to each other.

One may say that music is simply a language of harmonic resonance; using notes that are related to each other through the structure of the key, we hear the

relationship of the harmonies created by multiple notes over time.

This is true as well about visual art: paintings use color and shapes to relate one element to another, to lead the eye as desired into the composition, and down a path of visual understanding. It is the relationship of the elements in a painting or a musical composition that makes us perceive beauty or dissonance.

Graphic designers know that the eye sees not the individual letter in a word, but sees instead the shape of the word. When a person initially learns to read, he has to first learn each letter and then learn each word, but as the words become more familiar he can read faster and faster. He is seeing the group of the letters as a word, and the word as a familiar shape, and no longer has to read each individual letter.

"Only when he no longer knows what he is doing does the painter do good things." —*Edgar Degas*

Once you begin to see groups in design they start to appear everywhere. They suddenly pop up in the most unlikely places.

Object-oriented programming uses relationships to define what programs can affect other programs: parent programs affect child programs, and ancestor programs affect the parental programming. They all affect the child object. The artist understands the

innate tendency of humans to group things that belong together; he uses groups to communicate.

Led down the primrose path

It is the responsibility of the artist to explore how the eye sees, how the ear hears and how the mind perceives Studies of visual perception have shown that the eye does not see like a camera. The eye sees over time, while the camera sees only an instant. The eye travels over a picture, led from one element to another. A good artist knows how to keep the interest of the viewer inside the picture by using well-known visual techniques to lead the eye around and around the image.

> *"The child is laughing: The Game is my wisdom and my love. The young is singing: The Love is my wisdom and my game. The old is silent: The Wisdom is my love and my game"*
> —*Lucian Blaga, 3 Faces*

The eye—because it can adjust to the image or to the reality before it—can see far more than a camera. A camera cannot make individual adjustments in the amount of light it will let in for each object in its plane of view. Instead, it can only set its aperture once for the whole picture. This is why shadow (or highlight) detail can be lost in a picture that was shot in bright daylight— the eye would be able to adjust its aperture for the darker

or lighter parts of the picture and see more detail there, but the camera can only set its aperture for only one approximate setting at a time.

A composer will use the structure of the music to lead the listener into his musical piece, in the same way an artist will set up a composition to lead the eye of the viewer around his image. Similarly, a choreographer, stage or film director knows how to control and direct the attention of the audience.

The element of surprise

Communication can take place because of the structure that contains the message. However, the structure by itself is not going to trap or hold the eye or ear for long, because the underlying matrix of the communication is bland by nature. The structure of the piece provides the backdrop for the element of surprise. A good composition sets up expectations in the viewer or listener.

Think of a good comedy: the straight man provides the background of conventions for the comedian to reverse. The expectations of the viewer set the stage for the comic surprise.

In visual art this is called the accent; it is used to great effect in fashion design, interior design, and graphic design. Accents work best as small, dissimilar items on top of a background of items that are similar to each other.

The accent is always the thing that is different from everything else, but it is the background of similar objects allow the accent to sing. In a composition the attention of the viewer is always drawn to the accent.

In the movie *Schindler's List*, the entire movie was shot in black and white, except for the red coat on the little girl. The director used the color of her coat to direct the eye of the viewer. The accent serves to break the rules of convention, focus the attention of the viewer, and leads the eye through the composition.

20

DIRECT ATTENTION WITH AN ACCENT

Create a collage of objects on a large sheet of paper. Fill the paper with similar objects. Place a dissimilar object on the composition. Now examine your work: what is the background and what is the accent? Notice where your eye is drawn.

Open up to ambiguity

Artists use ambiguity as one of the tools in their toolbox. Ambiguity engenders tension—tension generates natural interest. Leave something hidden, or better yet, half-hidden, and our natural curiosity is aroused. We are unable to resist the power of our imagination—what is hidden is more interesting than what is obvious.

Humans are not much different from other mammals in our love of ambiguity. A cat may show some interest in a string dragged upon the floor, but it will show more interest when it starts to disappear under a carpet wrinkle, and pounce just before it is gone entirely from view. Why? The cat knows that the string is not a live mouse, but its imagination is triggered by the imminent disappearance of the tail-like string.

It was a shotgun wedding

Once the artist has learned a few rules it is time to break them. Questioning the rules brings all kinds of interesting ideas and can result in a single painting or a lifetime of work.

21

ARRANGE A MARRIAGE

Find two dissimilar objects, lay them inside an empty frame on the floor. Now find a way to make this marriage work. Is putting these two objects in close proximity enough? Do you notice that your mind is uneasy about the alliance, and is forced to draw unusual conclusions?

The artist may decide to put together dissimilar, unrelated objects in close proximity. This is called an *arranged marriage*. Surreal artists use arranged marriages

201

in their art to force the mind to unusual conclusions, and uneasy feelings. We are at once intrigued and disturbed by unusual relationships.

An arranged marriage can be anything from an unexpected pairing to an uneasy alliance. Surrealists were masters of arranged marriages; they invented visual and word games based upon chance.

Surrealism is a form of art that communicates directly with the subconscious. René Magritte used non-descriptive titles in his work, deliberate ambiguity, and uneasy relationships in order to force new metaphors and parallels. In this way, he directly addressed the subconscious or the right-brain without engaging the rational left-brain.

22

GO GESTALT

For the next few days try to find typos in printed materials and accidental groupings of images in photographs. Notice how your mind naturally jumps to the easiest conclusion and makes natural connections. How can you use this information in your work and in your life?

Quantum synaptic leaps

Creative intelligence is non-linear. It jumps across the chasm between disciplines, and takes inspiration

from unlikely places. Gestalt psychology explores many interesting ideas, and has strong correlations with art because it is a science that is focused on how we perceive. Gestalt psychology states that the brain takes the easiest path in comprehending an image.

For instance, if a photo was taken of a man standing in front of a set of shelves with a hat on one shelf at the level of his head, the mind will quickly assume that the hat is on the man's head. A perceptual mistake like this is a visual pun.

The play is the thing

Remember the formula for youth in Chapter Three? I didn't tell you which of those ingredients was the most important of the three. Now is the time to explore the "ability to be silly." An artist works without expectation of reward, and sometimes does things without any reason: this is the "play without purpose" from Chapter One.

> *"Let my playing be my learning, and my learning be my playing."—Johan Huizinga*

Johan Huizinga in his seminal book, *Homo Ludens* recognized the importance of play in the development of civilization. He stated that all science, art, culture, and technology had their genesis in the natural instinct of play. Play is not games, because games have a goal or

purpose. Play has an intrinsic value; it should be done for its own sake, for the simple joy of playing.

Play, according to Huizinga, should be properly extended throughout life, and practiced into adulthood. I know of no better excuse to play as an adult than the practice of art.

In her book, *slow is beautiful*, Cecile Andrews echoes the emphasis I have put on the importance of play in creativity:

> *"Play is purposeless...Play is absorbing... Play is time away from ordinary life...In play you forget about self-consciousness and express yourself freely...Play is, more than anything else, the expression of the pure joy of being alive, an expression of our true nature, of the big bang, that original flowing forth of the burst of life and light that we recapture when we give ourselves over to pure play."* [1]

Pure creativity starts with a mind freed of material or commercial concerns—the permission and ability to act without a defined purpose. To a left-brain person, acting without reason or purpose is absolutely silly.

But being silly is good, because it relaxes the mind so it can play. It is in relaxed play that new ideas naturally develop. When the famous act called *Stomp*

1 Cecile Andrews, *slow is beautiful, new visions of community, leisure and joie de vivre* (Gabriola Island, BC, Canada: New Society Publishers, 2006), 117

204

first started, the originators were just playing around with the ordinary objects around them: Now *Stomp* is a world-famous theatrical event.

> *"I started by banging a single drum on a strap around my neck, but I also started to improvise on the objects around us: bicycles, lampposts, policemen's helmets..."*—Luke Cresswell, Director of Stomp

The magic of not-doing

Carlos Castaneda's famous books introduced the concept of *not-doing*. Not-doing is the opposite of doing, a term that describes automatic, unconscious and habitual activity.

Not-doing is an extremely powerful way to get rid of negative thoughts and beliefs. My practice of thinking upside-down is a mental example of not-doing, and it is one of the keys to creative activity. You might think not-doing is inactivity, but, on the contrary, it is an action that acts to dispel habitual thinking.

A doing is full of self-importance; it keeps you inside the world of serious, average people, doing the serious, average things that everyone else does. In a doing, you are part of the unconscious structure of human society. In contrast, the perfect not-doing is independent, creative, spontaneous, lighthearted, and inspired.

The geniuses of every epoch did not achieve their masterworks by practicing the doings of their day. They practiced not-doings regularly.

As Einstein thought on relativity, or da Vinci drew diagrams for the helicopter that would only be able to be tested centuries later after an engine had been invented, the average people of their day were spending their time practicing their habits and routines.

Doings belong to society, and as habitual reactive activities, they keep us from being fully developed independent-thinking individuals. Not-doings free us through the magic of creative action. Highly creative people break the habits and doings of their day.

> *"And what is the purpose of writing music? One is, of course, not dealing with purposes but dealing with sounds. Or the answer must take the form of paradox: a purposeful purposelessness or a purposeless play. This play, however, is an affirmation of life—not an attempt to bring order out of chaos, not to suggest improvements in creation, but simply a way of waking up to the very life we're living."*
> —*John Cage*

Composer John Cage made compositions that were total not-doings from conception to final realization. At a time when tradition decreed that music must be

harmonious, he composed music from dissonance and silence.

According to John Cage, the purpose of art is to enhance awareness. Every part of thinking creatively and making art is an exercise in increasing awareness, from the exciting zing of inspiration, to the sensual mastery of materials, to the molding of the outer form, to the final resolution of the piece and its consumption by the viewer.

> *"Wearing a rubber nose wherever I go has changed my life. Dullness and boredom melt away. Wearing underwear on the outside of your clothes can turn a tedious trip to the store for a forgotten carton of milk into an amusement park romp. Humor is the antidote to all ills. People crave laughter as if it were an essential amino acid. I believe that fun is as important as love."*
> —Patch Adams

It is the job of the artist to look at the world in ever-fresher ways. Many people may be shocked at the prevalence of not-doings in the art world. The conscious creative is an adept at not-doings. He practices them on a daily basis. If taken to an extreme, a life that revolves around constant conscious perceptual reversals becomes a doing in itself.

The Belgian painter René Magritte retreated behind a facade of a bland bourgeois—bowler hats, middle class drawing rooms, and Sunday newspapers— all the trappings of a suburban existence. His work and his life were a complete not-doing. He enclosed his unusual perspective within a life of apparent normalcy.

Doings are of two kinds, the *doing* of the world and your own personal *doing*. For example a universal doing may be that of wearing matching socks, or facing forward in the elevator.

A good not-doing would be to deliberately wear mismatched socks to work, or face the rear wall of the elevator. The value of not-doing is that it helps put a crack in one's own self-importance; it dismantles habits, beliefs, and makes you more aware.

> *"A writer should write with his eyes and a painter paint with his ears." —Gertrude Stein*

Doings buttress self-importance, while not-doings undermine self-importance. A doing is easily identified by how quickly people will react to its polar opposite. Facing the back wall can guarantee a reaction by your fellows in the elevator. Not-doings are a great source of humor. I would go so far to say that doing a not-doing-a-day is a good prescription for mental health.

Exercise: The not-doing of making art.

Tourist for a day

Use a camera to shoot pictures of your home as if you are a tourist, only you are not going to use film or, if it is a digital camera, just pretend you are clicking the button. Can you can remember your day better because you took "pictures" of everything?

Invisible paint

Use your fingers as brushes; imagine that you can squeeze color directly from your fingers onto your canvas: each finger represents a color: the index finger on your right hand is white, the middle finger is cobalt blue, the ring finger is cadmium red, etc. Make a really elaborate painting, with layers and glazes and detail. Title, frame and hang your work when done.

The theater of the absurd

Recreate a famous speech or remembered event in your life by running it backwards. Speak the lines in reverse, and move in reverse. Run the performance forward, fast-forward or in reverse, just as if on tape or DVD.

The more seriously you take your not-doing, the more creative you are in setting it up, the better the final result will be.

The practice of art is a not-doing in itself. Free of the heaviness of doing and the gravity of self-importance, the artist enters the field of pure creative potential.

"Our deepest fear is not that we are inadequate. Our deepest fear is that we are powerful beyond measure."
—*Marianne Williamson*

THE INFINITE SELF

The value of creative thought becomes clear once the emotional and mental states are healthy. Self-imposed fears and limitations disappear one-by-one as the artist hones his skills, practices his art, and opens his mind. The principles of creativity help release the artist's creativity and refine his art:

1. Creativity is play without purpose. The artist has a license to play with everything that he sees, with everything that happens to him. When his play has no defined purpose or commercial value, it has the potential to be art.

2. Creativity is unconventional. Imagine that every day that you look out your window you see a different

landscape—imagine that every time you read the same sign, you see a different message. That is what being an artist feels like.

3. An artist is a keen, detached observer. Observe everything as if you are in a lucid dream, with absolute presence, observation, and awareness.

4. Creative action involves the capacity for introspection and time for incubation. Cultivate your own company and spend time by yourself. Introspection can be the most rewarding investment you have ever made. Being alone is not loneliness. Reward yourself with the gift of time.

5. Creativity is direct and spontaneous. Don't wait for someone to approve or for the right time to respond to the creative impulse. Have fun and just do it.

6. Creativity is fearless immersion. Dive into your material, into your medium, into your subject. Wade in it, walk in it, wallow in it; allow yourself the pure sensual pleasure of making your art.

7. Simplicity is to creativity as the match is to the flame. The tiniest inspiration can spark the most amazing conflagration.

8. Shift focus for inspiration and knowledge. Shift focus often to change your perspective. The ability to shift and change focus easily is the hallmark of flexible and fertile mind.

9. Limitations are advantages. An artist knows that everything is useful; the most useful items in her toolbox are what other people think of as limitations.

10. The creative process usually proceeds from the simple to the complex. It's easy to make a simple concept proceed to a complex realization; it is harder to make a complex thing simple, though that too, is an essential part of the artistic process.

11. Creativity is a lifelong romance with knowledge. An artist never stops growing his knowledge—his curiosity is insatiable.

12. Creativity depends upon unbiased observation. Seeing is different from looking: seeing means that one observes without prejudice. The artist knows she has reached the pinnacle of unbiased observation when the object she is observing loses its name.

13. Creativity is not judgmental. Never judge yourself and what you are doing in the moment of inspi-

ration or creation. Later, you can use your experience and judgment to refine your work.

14. Creativity is sideways thinking. Turn your artwork—or your world—on its side. Look at it from one eye, then from the other.

15. The artist bares his heart and soul. An artist puts his entire heart and soul into his work. Like a person who has finally learned what it is to love unconditionally, the complete unabashed honesty of the artist is what makes her work so powerful.

16. Creativity is passion sustained. Nothing moves the artist to create like passion, nothing nourishes the artist like passion sustained.

17. The creative mood is one of ease, lightness and play. Play is easy, play is light, and play is fun. Life lived from this attitude is a life filled to the brim with amazing experiences.

18. The creative attitude is one of limitless opportunity. Go ahead, explore; just because you took one path doesn't mean that you can't in the very next moment change your mind and go another way. Rather than allow yourself to be confused by the unending choices, simply take the one that appeals the most.

Soon, you will come to another place with another set of choices, and another decision to be made. Every path that you take opens more opportunities.

19. Creativity is nonlinear synthesis. Like the flight of the butterfly, the spirit of inspiration floats at the whim of the breeze, without rational rhyme or reason.

20. The creative process is not a search for anything in particular but an unending series of amazing discoveries. As an artist works, he discovers new techniques, ideas, innovations, and feelings.

21. A creative mind questions everything. Question everything, especially your habits and point of view.

22. An artist practices artlessness. Be unafraid to be direct and simple. Spend time with children; they are the masters of the art of artlessness.

~~~

**The function of art**

What function does art perform? It is not necessary for existence, in fact most people would place the practice of art far behind going to a ball game. They would buy a sofa before they would buy an original painting. Why, in the world, are some of us

drawn to making art? Perhaps it is because art does some things that nothing else can:

**Art gives us perspective.** As if we are on a high hill, looking down, we can see the past, we can see the future, we can see through others, and see inside ourselves.

**Art heals us.** There is no pain, no experience that is too painful or traumatic for art to heal. The healing is for both the artist and for the viewer.

**Art is an endless horizon for the intrepid explorer.** You can never get to the end of things to explore, express, or discover.

**Art is a safe way to express the inexpressible.** It gives us a way to deal with things that otherwise may be too dangerous for us to confront openly. The outer shell of art is like an iron-clad container over a hazardous substance. It gives us distance that makes the subject safe for contemplation and resolution.

**Art gives us wisdom beyond our years.** The artist is ageless, eternal, and has access to all of human experience, from the most extreme folly, to the deepest wisdom from the ancient past.

**Art gives us something of permanence in an impermanent world.** The thing that is most valuable is not your money, your house, or jewelry, but your experience, and what you create with it.

**Art gives us knowledge beyond ourselves.** Art references a rich history and language of archetypes, metaphors, and the full scope of human history. An artist has unlimited access to the vast library of all human experience and knowledge.

**Art allows us to be fully alive.** It gives us the opportunity to be fully here, to be engaged in this wondrous life, to be in our senses, to be "out of our minds" and absolutely in love with this amazing world.

**Art keeps us young.** As an artist we can be a child to the world, forever.

**Art gives us freedom.** No matter how dire your situation or circumstances, if you have a creative mind, you are free.

**Art allows us to be fully conscious.** A creative person is conscious in a way that others are not. The decision to lead a creative life is a conscious act, therefore it is a creative act.

**Art allows us to evolve.** It is said that the only way for humans to continue to evolve is through consciousness. There is nothing more conscious than creative thought.

~ ~ ~

## The art of life

Many people say that they envy creative people, or that they want to be more creative, if they just had the time, or the right materials, or a proper studio, but in the end, these are just excuses. It is in the practice of creativity that one learns how to be creative. It is in the practice of art that one exchanges the dullness of daily routines for the excitement of a life lived in the light of conscious creativity.

*"Phone home."—E.T.*

All great artists know that the long, roundabout journey to become a master artist is, after all, a return to the innocent state of childhood. In the end, all the schooling, all the understanding of psychology and perception, all the long study of craft and the careful honing of skills, all the knowledge of the history of art and culture cannot help one be more creative.

The fact remains that the best way to be an artist is to simply decide to *be* an artist. The knowledge of how to create has always been within us, from day one of our individual existence.

It is our birthright to be creative, just because we are human. The most successful artist is the artist who can return to the innate knowledge and inspiration he originally had as a child.

**Follow your bliss**

One of the things I have discovered is that the universe is built on a set of paradoxes. So it is with art—at the base lies an essential and inescapable paradox: while the subject of art is always the artist himself, the path of the artist takes him outside himself. The artist's journey of exploration eventually becomes more an exploration of who he *is not*, rather than an expression of who he *is*.

It takes courage to follow your muse, because she will lead you down unfamiliar paths towards an unforeseen destination. The practice of art leaves the conscious creative in a world full of opportunity and magic.

If what is written here resonates with something inside you, then you will be drawn by these words to find other sources of that same truth. You and your destiny become magnetized by each other.

As you become aligned with what you want, more and more of what is most like you will be drawn to you. Life becomes what it should be: a joyous magical adventure. All this is because you made the decision to become what you are: a conscious creative.

Living a creative life returns rewards far beyond the time and passion you invest. Walking the creative *path with heart* is immensely rewarding. It doesn't matter where your heart leads you, it is only important that you trust it to guide you well. The practice of art takes you on an incredible journey that leaves you in a strange and beautiful land far, far away from your point of origin.

The most amazing thing about a creative life is how it transforms your own perspective. Everything that happens to you is a creative opportunity that you can use. Your experiences are the paint, your skills are your brushes, and your life is your canvas.

The art you create is you.

About the author

Aliyah Marr is a multimedia artist, graphic designer, and educator. She has explored painting, illustration, design, artistic gymnastics, sculpture, music, dance, poetry, prose, and improvisational humor. As a visual artist, she works in a variety of mediums from painting and sculpture through to interactive art and video. Her work has been exhibited nationally and internationally, and may be seen at: *radi8.org.*

A graphic designer (*freshasylum.com*) with a stellar client list of Fortune 500 companies, the author is a creative consultant for companies and entrepreneurs. As an educator, she has taught graphic design, art, interactive programming, and new media at Parsons, Pratt and The School of Visual Art in New York City. She teaches design through online tutorials for Media Bistro.

Currently the author is working on her next book on creativity and is available for seminars, speaking engagements, and private coaching. Her books, images, and interactive games may be found at: *parallelmindzz.com.*

www.aliyahmarr.com
www.freshasylum.com
www.radi8.org

~~~

www.parallelmindzz.com
Toys & Tools for Creative People

221

APPENDIX

If you are in an emotional meltdown or lost in mental confusion remember to:

C ONNECT WITH YOUR INNER CHILD
O BSERVE DISPASSIONATELY
P LAY INCESSANTLY
E XPRESS YOURSELF

The following anagram helps you recall the most important creative principle of all. Don't forget to be:

O BSERVE EVERYTHING
P LAY INCESSANTLY
E NJOY EVERYTHING
N URTURE THE CHILD

The following is a list of the exercises from the book. Copy them and post the copy on your refrigerator or on the wall at work.

1

RECORD YOUR INTERNAL DIALOG

We all talk to ourselves, whether we do it out loud or not. The problem is that these opinions and negative thoughts are going on at a subconscious level. Bring them up to the surface by keeping a diary of your internal dialog throughout the day. You might be amazed at what is being said about you by your other self, and what thoughts are defining your world.

2

INTERNAL WISDOM

Take a sheet of paper and use it to send messages from your right-brain to your left. State a personal problem with your dominant hand on the corresponding side of the paper, and answer with your non-dominant hand on the other side. Repeat until your thoughts can flow freely from each side without any prejudgement or hesitation. Sit back, admire your work.

3

BOTTOMS UP

Sit on your couch or overstuffed chair upside-down. Not only is this good for circulation, but it changes your point of view. Observe the undersides of things.

4

RECALL YOUR CHILD GENIUS

Take a moment, close your eyes, and allow yourself to remember your childhood thoughts. Did you have any notions that were dismissed by others? In retrospect, do you think any of your ideas had merit? How would you treat a child today who had these ideas?

5

REMEMBER YOUR DREAMS

Just before you drop off to sleep tonight, make a promise to yourself to remember your dreams. Place a dream diary by your bedside and vow to write your dreams down first thing in the morning. Give each dream a title, and write the contents of your dream on the right side of the notebook, use the left side for dream interpretation.

6

RISE AND SHINE

When you wake up in the morning, spend a few minutes lying in bed, visualizing good health in every part of your body. Feel it flowing like an electrical current or pleasurable tickle throughout your body. Run it up and down a few times, stretch, and give thanks.

7

CHANGE THE SUBJECT

Try this well-known artist trick: form a camera "lens" with your thumb and your forefinger and look through it using one eye. Notice what you have in the foreground and in the background. Move your hand to change subject matter, shift focus from the foreground object to the background and visa versa.

8

THE MEDIUM IS THE MESSAGE

Next time you are working, ask yourself this most basic of questions: "What would happen if I change the format, size, structure, or medium; how would this decision affect the impact of this piece?"

9

CHAIN REACTION

Track your thoughts and beliefs back in time. Examine a pet peeve. What emotion do you experience? What thought engendered the emotion? What event triggered the thought? What was the first time you remember this happening to you?

10

TOUCHBASE

Imagine or remember the feeling of joy. How did it physically feel? Where was it located in your body? Now, do this same thing with fear, excitement, and every emotion you can imagine.

11

OBJECTIVE OBSERVATION

Stare at an object with a soft gaze, empty your thoughts and see it as if you have never seen it before. Notice everything about the object, see it without reference to its function, history, or aesthetics.

12

PLAY WITH SYNTAX

Here is a fun way to use syntax. Take any written text that you see: the titles of the books on your bookshelf, or a line in a magazine article; switch the words around. Sometimes the sentence works, other times it makes no sense at all, and at other times the new order has a different meaning altogether.

13

HAPPY ACCIDENT

Set up yourself up for a *happy accident.* Be inventive according to your chosen medium. Allow paint to run freely over the surface of your painting. Go out into the street and record whatever sounds you encounter to use in your music. Sample text from a magazine and create a poem.

14

GATHER AND FLOAT

Take a mini vacation today and wander around freely; pick a location where you will see unique and random interesting things. Draw no conclusions, make no judgements, and force no events.

15

PRACTICE NAIVETE

Look around you. See an object and ask a deliberately simple question. Simple questions can spark both sublime and ridiculous ideas. Dare to ask a naive question.

16

SIMPLIFY AND REDUCE

Find a photograph in a magazine. Using tracing paper and a pencil, try to reduce the image down to its most basic shapes: squares, circles, and triangles. All these shapes can be found in everything we see. Observe how everything around you can be reduced to a simple form.

17

SHIFT FOCUS

Try changing focus right now: look up from this book and into your room or out the window. Focus on an object in the foreground and then on one in the background. Practice switching your focus back and forth between objects a few times. See how everything else in the background and in the periphery of your vision becomes blurred and indistinct.

18

NOTICE NEGATIVE SPACE

Take a break and spend some time noticing negative space in the world around you. It is everywhere in life, in art and in our minds. Look at a tree and see the space between the leaves, look at the space in the world around you.

19

FORM GROUPS & FAMILIES

Take a bunch of unrelated items and see how many groups you can make from them. There are many ways you can group things: by color, function, size, etc. Then take one of the groups—say a group of red items—and scatter them over a monochromatic background. See how the family of red remain related to each other.

20

DIRECT ATTENTION

Create a collage of objects on a large sheet of paper. Fill the paper with similar objects. Place a dissimilar object on the composition. Now examine your work: what is the background and what is the accent? Notice where your eye is drawn.

21

ARRANGE A MARRIAGE

Find two dissimilar objects, lay them inside an empty frame on the floor. Now find a way to make this marriage work. Is putting these two objects in close proximity enough? Do you notice that your mind is uneasy about the alliance, and is forced to draw unusual conclusions?

22

GO GESTALT

For the next few days try to find typos in printed materials and accidental groupings of images in photographs. Notice how your mind naturally jumps to the easiest conclusion and makes natural connections. How can you use this information in your work and in your life?

Also by Aliyah Marr

Celestial Navigation
*Words of Inspiration & Comfort for the Explorer of Creative
Consciousness, Personal Evolution,
& Social Change*

Pocket Parallel Mind
-365-Days-of-Creative-Inspiration-in-Your-Pocket-

Transformational Tarot
a game for creative & personal transformation

~~~

Find these products and others at:

www.parallelmindzz.com
*tools & toys for creative people*

Breinigsville, PA USA
14 January 2011
253357BV00001B/1/P